Weegee and *Naked City*

Defining Moments in American Photography
Volume 3 of a series edited by Anthony W. Lee

Weegee and *Naked City*

———

ANTHONY W. LEE

RICHARD MEYER

Published with the assistance of The Getty Foundation

———

University of California Press

Berkeley Los Angeles London

The publisher gratefully acknowledges the generous contribution to this book provided by the Art Endowment Fund of the University of California Press Foundation, which is supported by a major gift from the Ahmanson Foundation.

Contents

Introduction

WHEN ARTHUR FELLIG's first photo-book, *Naked City,* was published in June
1945, it enjoyed spectacular commercial success, going through six printings
by December of that year alone. Initially sold at four dollars a copy, *Naked City*
quickly became the most profitable photo-book in the history of American
photography. A paperback version is still in print. Although hundreds of pho-
tographers had been taking pictures of New York throughout the 1930s and
early 1940s, *Naked City* emerged as the most widely known single-volume
visual representation of the city. Sensation was the book's calling card. Fellig's
images of crime scenes, tenement fires, and boisterous crowds contrasted
sharply both with the cool, precise modernist photographs of New York sky-
scrapers by such famed photographers as Alfred Stieglitz, Lewis Hine, Berenice
Abbott, and Margaret Bourke-White and with the documentary pictures of
the city's residents by the equally famed Walker Evans, Ben Shahn, Morris En-
gel, and Arthur Rothstein.

Beginning in 1935, Fellig had labored nightly as a hustling street photog-
rapher who monitored the police radio, chased ambulances and paddy (or
"pie") wagons, developed his negatives on the fly, and sold his prints in the
wee hours of the morning to the newspapers, magazines, and photo agen-
cies. By the early 1940s, Fellig had made a name for himself as a freelance
photographer with an almost preternatural ability to arrive at crime scenes

before other photojournalists—and, sometimes, before the police—had done so. The name he made in the press was not Arthur Fellig but "Weegee"—a catchy moniker that referred to his uncanny prescience or Ouija-like knowledge of the city and its vices.

Precisely when Weegee began to cull a choice number of his freelance photographs and sequence them into a book is unknown, but certainly by early 1945 he had approached and been turned down by a number of publishers. It was not until William McCleery, a friend and sympathetic editor, intervened on Weegee's behalf at Essential Books that the project found a taker and was transformed into *Naked City*. McCleery ended up writing the foreword to the book, a feature that Weegee, in appreciation, kept in nearly all subsequent reissues.

In addition to McCleery's foreword and a preface titled "A Book Is Born," Weegee divided *Naked City* into eighteen chapters spanning the subjects for which he was then most recognized: "Fires," "Murders," "Sudden Death," "The Opera," "The Bowery," "The 'Pie' Wagon," "Coney Island," and more. He introduced each chapter with a brief essay and followed it with ten to twenty-five photographs, usually one to a page. Only the last chapter, "Camera Tips," contains no photographs. Many, though certainly not all, of the photographs carry captions. Some of the captions are brief and breathy ("Sudden death for one . . . sudden shock for the other," for example, accompanies pictures of two drivers after a car crash).[1] Weegee made liberal use of ellipses to suggest a broken conversational tone or a string of loosely connected thoughts about the photographs, what some of his contemporaries ungenerously called a narrative voice befitting a "short, dumpy man in his 40s with a penchant for cigars."[2] In some cases, he wrote captions that are long and storylike, functioning in conjunction with the pictures as self-contained vignettes. For example, he accompanied a scene of a man and child fleeing a burning building with the following: "This man was lucky . . . he hadn't gone to bed as yet . . . but the rooms got full of smoke . . . the lights went out . . . so he grabbed his kid . . . without the kid's shoelaces . . . and ran for his life. He is surprised to

find me there with my camera. He must wonder if my studio is on the fire engine . . . and if I sleep in the Fire House" (58). In other instances, he omitted captions entirely and the full-bleed photographs constitute a strictly visual sequence. There is no overall story or driving narrative in *Naked City*. Rather, the photo-book is a kaleidoscope of words and images, grouped together in subjects drawn from Weegee's experiences as a photojournalist. It moves from blood-spattered gangsters on the streets of Hell's Kitchen to opening night at the Metropolitan Opera to Sammy's bar on the Bowery, from the circus to a ball at the Waldorf-Astoria.

Following the success of *Naked City* and the national publicity it garnered, Weegee gave up his job as photojournalist, relocating to Hollywood in an attempt to become a filmmaker and actor (indeed, his book became the basis for a film, and over the next twenty years he would have bit parts in seven features and a hand in making eight short and mostly forgotten experimental films). When his film career foundered, he turned to writing, lecturing, and promotional endorsements. When he returned to his camera in the 1950s and 1960s, he pursued trick photography, distortions, and soft-core pornography—or, as he preferred to call all three, his "art." Weegee never went back to the kind of gritty, spontaneous street photography that constituted *Naked City* and made his reputation.

In this volume, we analyze the meanings of this important American photographer and his signature work—asking and answering, among other things, how and why Weegee and *Naked City* achieved their fame, how his photographs may have competed with or displaced other images of New York City, and how the photographer informed and was in turn formed by the aspirations of a newspaper culture. In doing so, we return Weegee and *Naked City* to their original social, economic, and professional conditions—to the New York of new immigrants and class divisions, of anxiety about as well as escapism from the Depression, and to the "tabloid city" in which Weegee emerged as a star of sorts, a freelance photographer who kept inserting himself before—as well as behind—the camera. We have titled this book *Weegee*

and "Naked City" both to echo the official title of the 1945 publication and to stress Weegee's role in framing and claiming the city he exposes to view. Although today his great book continues to define the image of New York in the middle of the twentieth century, our analysis suggests the extent to which it grew out of a specific photographic practice and, in an important historical sense, how it signaled an end to that practice and the era that produced it.

The cultural historian Warren Sussman has argued that the rise of the picture press in the 1920s, alongside that of "cartoons and comics, increasingly visual advertising, and motion pictures," created a "new knowledge of the world" predicated on visual experience. Sussman points, in particular, to the role of "the great tabloids like the *Daily News* in New York, which began in 1919 to make a heavy investment in photographs (often real, but sometimes artfully concocted), and the playful and sensational use of various kinds and sizes of prints. By the late 1920s, they were essentially designing for well over a million readers a special definition of what was 'news,'" a definition bound ever more closely to photographic information and less to "the old ways of knowing available in the book and the printed word."[3] The launching of *Life* in 1936 as the first "all photography" news magazine capitalized on and came to embody what we might call, following Sussman, an expressly visual "knowledge of the world."[4]

Weegee's career was coincident with the rise of photography in the illustrated press and, through it, the special photographic cultivation of visual knowledge. Weegee, as we demonstrate, was a central player in this crucial and defining moment in the history of American photography. We also argue for the strategic ways in which he tried to capitalize on photojournalism's still-formative stages and its new "ways of knowing" the world. We show how his efforts—canny, premeditated, self-conscious—were eventually transformed into the logic, layout, pictorial style, and sensibility of *Naked City*.

Although we insist on seeing Weegee as part of his photojournalistic times, we do not always agree on how we should interpret that relationship or how his photographs, including those collected in *Naked City,* grew out of it. Draw-

ing extensively on many of the same archival materials and original printed matter, we allow the reader to mark and assess our differences. For example, both of us view Weegee's early experiences exhibiting his photographs as important precursors to the selections and strategies found in *Naked City,* but we understand those exhibitions (figure 1) and their impact in competing ways. For Richard Meyer, the exhibition of Weegee's pictures marks the successful infiltration of a tabloid imagery and flamboyant persona into the sphere of the fine arts. Rather than attempting to elevate or aestheticize his photographs, Weegee continued to insist on their lowbrow appeal. For Anthony Lee, the exhibitions indicate Weegee's engagement not with the fine arts but instead with activist photography. But ironically, that engagement with images of social consciousness—of poverty and loss during the Depression—became the basis for *Naked City*'s expressive statements about New York's glamorous sordidness. In general, Meyer emphasizes Weegee's genius for self-promotion and photographic sleight of hand and links the success of *Naked City* to the sensational appeal of the tabloids and to the "irresistibly hard-boiled" character of the photographer-detective (figure 2). In contrast, Lee shows how Weegee's photographs participated in the left-leaning photojournalistic cultures of his day, especially at the progressive newspaper *PM Daily,* and understands the photographer as "a portraitist of the immigrant working classes," a portraitist who both exploited and expanded the "human interest story."

Although Weegee is widely acknowledged as a seminal figure in American photography, he has often proven an elusive figure to study—even though he wrote an autobiography, gave dozens of interviews, appeared on a nationally syndicated radio broadcast, and penned an impressive array of articles and books.[5] Part of the reason for his elusiveness is that he happily fabricated details about himself to suit the needs of the moment. In a sense his pseudonym, both in the magical clairvoyance it summoned and the homespun quality its made-up spelling suggested, typified Weegee's imaginative latitude. Even the pseudonym had competing origins, since it recalled both Weegee's self-professed "sixth sense" about the city and his early, low-level job as a "squeegee boy" at

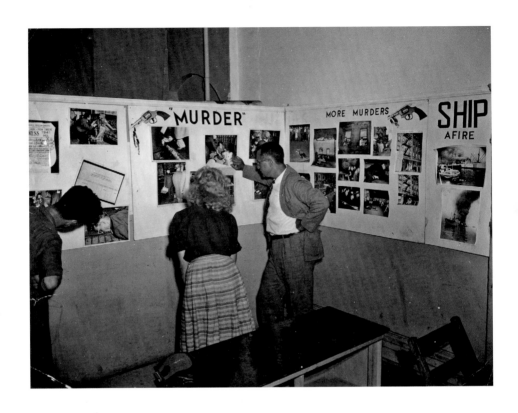

Figure 1 Weegee (Arthur Fellig), Installation view of Murder is My Business, Weegee exhibition at the Photo League, New York, 1941. © Weegee/International Center of Photography/ Getty Images.

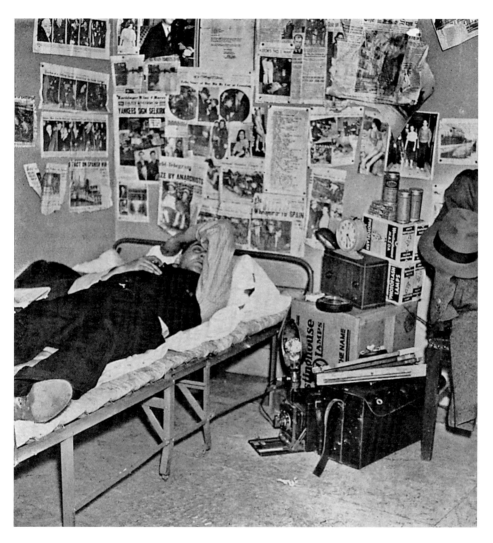

Figure 2 Weegee (Arthur Fellig), "The Fellig Home." In "Speaking of Pictures . . . A New York Free Lance Photographs the News," *Life*, April 12, 1937, 8. Copyright 1937 Life Inc. Reprinted with permission. All rights reserved.

Acme Newspictures, a New York–based photo agency. Depending on his mood, Weegee represented himself as a man of mystique ("Ouija") or of everyday labor ("Squeegee"), or anything in between. Although he was a photojournalist with an eye for detail, he often had limited interest in the accuracy of facts, especially those about himself.

As far as can be discerned, Weegee was born Usher Fellig in 1899 in what was then Austria (now Ukraine). He was the second of seven children in a devout Jewish family. Like many Eastern European Jews at the turn of the century, the Fellig family gradually immigrated to New York—first Weegee's father, in 1906, and then the rest of the family, in 1910. Upon his arrival, "Usher" became "Arthur." As a child, Weegee had a minimal education. By age thirteen or fourteen he had dropped out of public school; by eighteen he had left the family's home, never to return. According to his own account, after leaving home he lived on the streets and slept on park benches, in shelters, or inside Penn Station. He worked a slew of odd jobs, including stints as a biscuit maker, candy mixer, dishwasher, and busboy.

In his autobiography, Weegee described how he came to photography. As a teenager, he explained, "I had had my picture taken by a street tintype photographer, and had been fascinated by the result. . . . That street photographer really started the wheels going around in my brain. I sent off to a Chicago mailorder house for a tintype outfit, and as soon as it came, began to take street tintypes myself."[6] However modest his initial camera work, by 1918 he could be found as an assistant at the Ducket and Adler photography studio in Lower Manhattan, three years later in the darkroom at the *New York Times,* and three years after that in the printing room of Acme Newspictures. Between 1935 and 1945 he worked as a freelance news photographer and published hundreds of pictures in the newspapers, magazines, and tabloids. His efforts as a freelancer, fiercely trying to scoop his competitors, were greatly aided in 1938 when he received permission to install a police radio in his car, purportedly the first photographer in New York to do so. By the time he published *Naked City* in 1945, he had amassed thousands of news photographs in his personal archive.

Before *Naked City* appeared, two key developments punctuated Weegee's career as a photographer. The first, in 1940, was his signing on with *PM Daily* as a contributing photojournalist. Previously, the wire services and New York's many newspapers, including the respectable *Post* and *World Telegram* and the trashier *Mirror* and *Daily News,* had published Weegee's freelance work. Together, they kept him in business. "One good murder a night, with a fire and a hold-up thrown in," he once proclaimed, "kept me in blintzes, knishes, and hot pastrami, with the nice feeling of green folding paper in my pocket."[7] But it was arguably at *PM Daily,* devoted to photography like no other paper before it, that Weegee got his biggest break.

There were many reasons why *PM* appealed to the photographer. While Weegee had to find a "good meaty story to get the editors to buy the pictures" at the other papers, *PM* gave him a steady salary and yet allowed him to remain a freelancer, free to keep selling to the wire services and *PM's* competitors.[8] And while the other papers usually refused to credit the pictures they used— "Once I did succeed in coaxing the *World Telegram* to give me a credit line," he remembered, "but in the next edition it was changed to 'Acme' again"— *PM* established a policy of naming individual photographers.[9] Nearly all of his published photos in *PM* carried the credit line "*PM* Photo by Weegee." In addition, the newspaper encouraged him to write his own captions and, quite often, the accompanying articles as well. To Weegee's liking, *PM's* attitude toward photographers was on a par with other papers' attitudes toward bylined writers: it acknowledged, even celebrated, the importance of his craft. Weegee was on retainer for $75 a week from 1940 to 1945—that is, from *PM's* beginnings to the publication of *Naked City.*

The second key development was Weegee's first exhibition of photographs as nominal works of art in a one-man show that took place at the New York Photo League in 1941 (see figure 1). Titled Murder is My Business, the exhibit attempted to capitalize on the gritty appeal and tabloid sensationalism of Weegee's photographs—victims of gunfire on city sidewalks, tenement fires, car crash fatalities—typically shot at night or in otherwise shadowy surrounds.

As a notice in the League's newsletter put it, "New York at night is cruel, brutal, human, and humorous. Come ready to be shocked."[10]

Although Murder is My Business traded on Weegee's tabloid reputation, it took the photographs away from their usual location and function (and disposability) in the newspapers. The exhibition signaled an important shift in how New Yorkers and others came to know Weegee's work—in the pages of *PM* and other newspapers as before, but increasingly also on gallery and museum walls. Two years after Murder is My Business, the Museum of Modern Art included Weegee in its exhibition Action Photography, invited him to present a public lecture at the museum, and acquired five of his prints for the permanent collection. In 1944, Weegee was featured in Art in Progress, a survey exhibition at MoMA celebrating the fifteenth anniversary of the museum's founding. The Photo League thus initiated the transfer of Weegee's work from the register of pulp journalism to that of exhibition-quality photography.

In what follows, we understand *Naked City* as the fruition of ideas spawned earlier in Weegee's career, first in the illustrated press and then in exhibitions like Murder is My Business. We try to make sense of the meanings of those original sources and their transformation into a best-selling photo-book. And we draw extensively on Weegee's massive archives and original publications that have been underutilized in the literature on him to date.

In contrast to other books in the Defining Moments in American Photography series, in which scholars from different disciplines tackle a common subject, *Weegee and "Naked City"* has been co-authored by two art historians. This approach suggests both the growing acceptance of photography in the art and museum cultures of the 1930s and 1940s and the crucial ways in which Weegee brokered—but also troubled—that development. We intend *Weegee and "Naked City"* likewise to expand, exceed, and question the category of art and, by extension, the protocols and limits of art history. We demonstrate how Weegee's photographs existed in a wider field of visual culture—of tabloids and broadsheets, pulp paperbacks, pornography, and the documentary. We link his photographs to the social conditions that shaped them, to patterns of col-

lective belief and individual self-understanding, to labor and class division, to political struggle and ideology.

Though our interpretations and emphases differ—one with a stress on Weegee's self-fashioning in the tabloid press, the other with a stress on the broader political and professional contexts surrounding him—we share the goal of offering new ways of thinking about Weegee's contributions to American photography and popular culture. By returning Weegee to his working world, we hope to better understand how that world shaped and was shaped by him, and ultimately how it became the stuff of *Naked City*.

Learning from Low Culture

———

RICHARD MEYER

The photograph has to tell a story
if it is to work as art.
—Clement Greenberg (1964)

ON AUGUST 5, 1936, the *New York Post* published a front-page story headlined "Gang Stabs B'klyn Man 48 Times." The article reported on the murder of "a young shakedown artist" who had been stabbed to death with an ice pick, stuffed in a steamer trunk, then dumped in a vacant lot. According to the police inspector in charge of the case, it was almost certain that the victim was murdered by gangsters, because "he was killed in a room by a group of men, every man in the room taking part. That's the usual procedure in such killings, as every man shared the guilt and is less likely to squeal."[1]

The *Post* story was accompanied by a photograph of a man in a dark suit and fedora examining the now empty trunk (figure 3). Rather than the plainclothes detective we might take him to be, the man is identified as an interested bystander: "A curious passerby peers into the trunk which held the body of a well-dressed man who had been stabbed to death in Brooklyn. Trunk and body were found near Gowanus Canal, and police believe the murderers were interrupted as they prepared to dump their victim into the water."[2] The article elsewhere mentions that "the body was found by a passerby" who subsequently alerted the police. The *Post* photograph seems to recall, perhaps even to reenact, this unhappy discovery.

The man in the photograph was not (or, at any rate, not simply) a curious passerby. He was Arthur Fellig, the freelance photographer who took the

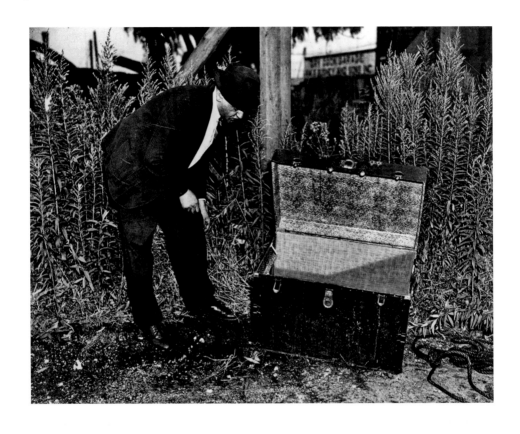

Figure 3 Weegee (Arthur Fellig), *Trunk in which slain man was found,* August 5, 1936.
© Weegee/International Center of Photography/Getty Images.

picture and sold it to the *New York Post* in 1936. As typically happened during this early stage of Fellig's career, the picture was credited not to him but to the newspaper that carried it (Post Photo) or, in other instances, to the syndicate that licensed its publication (Acme, Wide World Photos). In this case, however, the absence of any attribution to Fellig parallels his similarly unacknowledged appearance within the frame of the picture. That Fellig posed as an inquisitive bystander at the very murder site he was simultaneously photographing suggests how his practice as a photojournalist could slide—or, perhaps better, bleed—into the scene of the crime. Far from being a dispassionate chronicler of someone else's demise, Fellig emerges as a character ("the curious passerby") in the unfolding story of the trunk murder. Although that character is, at best, a bit player in the written account of the story, he is the central, indeed only, figure in the photograph that illustrates it. The intrusion of the photographer into the visual field coincides, in this case, with the disappearance of the body we expect to find there: the body of the murder victim.

A further sleight of hand involved in the trunk murder photograph was revealed in April 1937, when *Life* magazine ran a two-and-a-half-page photo-essay about Fellig titled "Speaking of Pictures . . . A New York Free Lance Photographs the News." The lead pictures for the story were two photographs of the trunk murder: one with the corpse still stuffed inside the box, the other—identical to that published in the *Post* the previous year—of the empty container (figure 4). The accompanying caption elaborated on the difference between the pictures, noting that "the expurgated trunk murder pictured above is the same as the one at left except the corpse has been painted out. This was done by the New York *Post* which feared that the corpse would upset its readers. Other papers printed the corpse with the picture in full view."[3]

Life explains Fellig's appearance in the photograph as a necessary convention of news photography ("editors demand people in pictures"), yet a number of questions remain unanswered by this tidy rationale: How did Fellig find himself alone with a corpse in a trunk? Had the police not yet arrived at the murder scene? Or were the cops there, perhaps just off-frame, allowing the

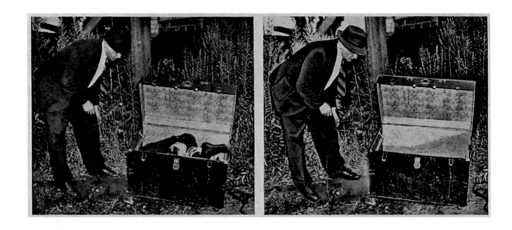

freelance photographer to set up his camera on a tripod, connect the shutter release cord, and then snap this peculiar self-portrait? Neither the arrival of the police on the scene, the investigation of the crime, nor the question of the victim's identity is ever mentioned by *Life*. By April 1937, the trunk murder was no longer news; it was now the photograph—and the terms of its manipulation by Fellig and the *Post*—that provided the focus of interest. *Life* was, after all, "speaking of pictures," not of the specific crimes they document.

Within a year of its publication, Fellig's photograph of a murder scene was thus lifted out of the local context and temporal immediacy of a *New York Post* news story and reframed, now for a national audience, as an object of pictorial interest in its own right. Under the heading "Speaking of Pictures . . . ," *Life* featured a photo-essay on a different, offbeat subject in each issue. Just the week before the Fellig story, for example, a suite of photographs taken in a Brooklyn catering hall appeared as "Speaking of Pictures . . . This is a Jewish Wedding." The week after it, an Indian-born, Yale-trained psychologist furnished photographs for "Speaking of Pictures . . . These are the Exercises of Yoga."[4] According to the editors of *Life,* "intrinsic picture interest and photographic literacy" were the "only standards" governing the selection of images for "Speaking of Pictures."[5] The feature was also one of the few sections in the magazine where the work of amateur or other photographers not on its staff might appear.

The "Speaking of Pictures" layout devoted to Fellig reinforced his dual status as both agent and object of "picture interest." Of the ten photographs in the opening spread, the photographer appears in six: the two trunk murders, a shot of Fellig climbing into a paddy wagon with camera in hand, another of him reading teletype reports at police headquarters, a picture of Fellig holding a toy gun to his head, and, most strikingly, an apparently candid shot of the photographer lying on an unmade bed in his own apartment (see figure 2). Fellig holds a (lit?) cigar in his right hand while bending his left arm across his head, as though resting momentarily or blocking out the light. According to the accompanying caption, "The Fellig home is this bare room

in a building opposite police headquarters in Manhattan. Here Fellig lives, sleeps, and spends his time when he isn't out taking pictures. His camera, bulbs, and tripod are all at hand to be grabbed up the instant news of a story comes in."[6]

However spartan, even shabby, Fellig's room is not quite as bare as *Life*'s text suggests. Alongside the camera with its large flashgun, carrying case, and cardboard boxes of photographic lamps, we see a chair onto which Fellig has thrown his wool overcoat and fedora—doubtless the same hat he is wearing in the trunk murder photograph. An alarm clock perched atop the radio reads 4:30, though whether this is A.M. or P.M. is difficult to determine, given Fellig's unusual working hours and sleeping habits. ("He sleeps in his clothes," *Life* reports, and "is ready night or day to dash out and take pictures.")[7]

But the most salient element of decor left unmentioned in the caption must surely be the riot of newspaper clippings pinned to the wall above Weegee's bed. A few of the larger headlines are just legible, in whole or in part ("Yankees Sign Selkirk" "A Pact on Spanish War," " . . . Ze by Anarchists"), while most fail, at this distance, to resolve into recognizable words. The effect is one of visual and informational overload as the clippings—some tabloid, some broadside, some front-page, some full-page—climb up, around, and beyond the visible confines of the wall. The densely packed traffic on Weegee's wall includes mastheads from several of the daily newspapers to which he was selling pictures at the time.[8] As though to reinforce the article's claim that "his work is his whole life," Fellig's private space is replete with the paraphernalia and pages of photojournalism. *Life* presents "the Fellig home" (the phrase is meant to be ironic) as little more than an extension of the photographer's (night-and-)day job.[9]

One key feature of Fellig's professional persona—his moniker, "Weegee"—was still in formation at the time of this article. *Life* mentions that "Fellig's associates call him 'Ouija,' because he often gets a feeling that something is about to happen and then something does happen."[10] The "something" in question was typically a murder, fire, or fatal accident, on whose scene Fellig would

often be the first to arrive. By 1938, "Ouija" had become "Weegee"; beginning in 1940, that name appeared on the hand-stamp inked on the back of his pictures ("Credit Photo by Weegee" and, ultimately, "Credit Photo by Weegee the Famous").

In an interview conducted almost thirty years after the "Speaking of Pictures" profile appeared, Weegee recalled the circumstances of its publication: "I used to go up to *Life* magazine and leave my pictures on the desk in the early morning hours. Finally they got curious and said, 'Do us a story on how you work around police headquarters.' So I did."[11] Weegee claims to have "done the story" for *Life* rather than simply served as its protagonist. Given Fellig's notorious unreliability as a narrator of his own life and work, how are we to gauge the credibility of this particular claim?

Seven months after the *Life* story, a similar feature article appeared in *Popular Photography* under the title "Free-Lance Cameraman." The story, which marked the first mention in print of the name "Weegee," included a variant of the "Fellig home" photograph (figure 5). In *Popular Photography,* Weegee wears what seem to be the same shirt, vest, pants, and shoes as in *Life* and, once again, holds a (lit?) cigar in his right hand. Weegee's left hand, however, now snaps a cable release mechanism, whose cord snakes down the side of his cot and out of the frame. "Photographer Fellig takes his own picture," reads the accompanying caption.[12]

Once we have encountered this picture in *Popular Photography,* we cannot but see the kindred photograph in *Life* as a self-portrait, though one retouched so as to erase the signs of its own making. Although the retouched version seems to capture Fellig in an unguarded moment of private relaxation, he remains very much on the job, manufacturing and manipulating the image of himself at rest in his room. The "Speaking of Pictures" feature in *Life* reveals one pictorial sleight of hand (the painting out of the corpse in the trunk murder photograph) only to conceal another (the painting out of the shutter release cable in the "Fellig Home" self-portrait). Weegee helped stage the terms of his own public reception by supplying the press a ready-made narrative (the hard-nosed,

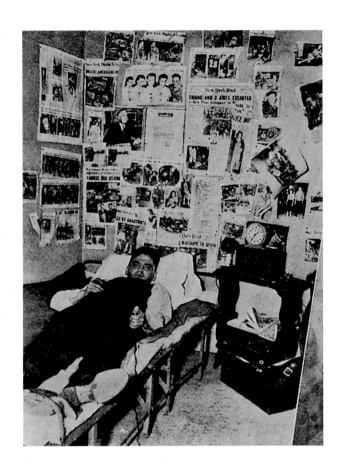

Figure 5 Weegee (Arthur Fellig), "Photographer Fellig takes his own picture." In "Free-Lance Cameraman," *Popular Photography*, December 1937, 21.

"sleeps-in-his-clothes" crime photographer) and the pictures (Fellig on his bed, in the paddy wagon, at the police station) to illustrate it.

Taken together, the trunk murder and "Fellig home" photographs point to the central concerns of this essay: the appearance of Weegee both in front of and behind the camera; the initial publication of his photographs in relation to their later recycling and adaptation; and the broader culture of self-promotion, photographic manipulation, commercial exchange, and sensational journalism in which Weegee participated in the years leading up to the publication of his first book, *Naked City*. Weegee's hard-boiled yet highly self-conscious persona as a crime photographer was crucial not only to the success of *Naked City* but also to the redefinition and eventual marketing of his photographs as fine art. Somewhat against the odds, Weegee and his pictures migrated from the tabloid news to the Photo League to the Museum of Modern Art. They did so, I argue, not in spite of their avowedly lowbrow appeal but because of it.

This essay returns Weegee's photography of the 1930s and early '40s to the mass-circulation newspapers and magazines for which it was intended—to the *New York Post* and *Life* magazine, to the *Daily News* and *PM*. One motive for this approach might be called compensatory: the extensive literature on Weegee includes no reproductions of the news pages, layouts, and picture essays in which many of his best-known (and now, most highly valued) photographs first appeared.[13] Even those scholars who have situated Weegee's early photographs in relation to tabloid journalism have not analyzed the visual logic of that relation in any detail.[14]

This lacuna is particularly surprising given the primacy of photography within the popular press of Weegee's day. Advances in halftone printing, synchronized flash, camera portability, and other photographic technologies allowed daily newspapers of the late 1920s and the 1930s to go far beyond the earlier confines of press illustration.[15] Large-scale, often full-page, photographs became increasingly prominent in the tabloid or "picture press" of the day.[16] Prior to this time, newspaper illustrations typically consisted of woodcut or

halftone engravings after line drawings, pen-and-ink sketches, or overpainted photographs.[17]

From 1935 to 1945, Weegee worked as a freelance photographer in New York City and sold pictures to photo agencies and newspapers as well as, more occasionally, to *Life* magazine and trade publications such as *U.S. Camera* and *Popular Photography*. Of the local newspapers, three—the *New York Daily News,* the *Daily Mirror,* and the *Evening Graphic*—were tabloid in format. In response to the success of the *Daily News* (which claimed by 1937 to have "twice the circulation of any other newspaper in America"),[18] the *New York Post* switched from broadside to tabloid format in 1942. Smaller in size than traditional, bifold broadsides, tabloids open like unbound magazines, with each page likewise taller than it is wide. Generously illustrated and set in relatively large print, tabloid articles are typically condensed so as to fit on one page without runover. They are thus easier to read in confined spaces such as public trains and buses. As the *Daily News* promised in its first editorial, "You can turn the pages in the subway without having it whisked from your hands by the draft. You can hang to a strap and read it without the skill of a juggler to keep its pages together."[19]

Throughout the late 1920s and early '30s, serious-minded publications such as the *New Republic,* the *Nation,* and the *Saturday Review of Literature* attacked the tabloids as vulgar and degrading—as, in the words of one *New Republic* editorial, "jungle weeds in the journalistic garden."[20] A full-page caricature in the June 15, 1927, edition of the *Nation* captures the contempt of traditional journals for their tabloid counterparts. The drawing, titled simply "The Tabloid," presents a large hog chomping a weed while standing in a puddle of mud. A caption printed beside the artist's signature bears the message "with apologies to the poor hog."[21]

Writing in 1937, the historian Alfred McClung Lee observed that the American tabloid had "reached widest acceptance only in our largest urban area," New York City. There its size and contents adapted to subway congestion and 'subway minds.' "[22] As Lee's note of contempt might suggest, the tabloids were

equated with a working-class, subway-riding readership whose dependence on visual sensation and local scandal was contrasted to the (supposedly) high-minded, literate, and worldly concerns of the readers of traditional broadside newspapers such as the *New York Times.*

For all their differences of both form and content, the tabloids and broadsides often overlapped in their local news coverage, their use of photo agencies such as Acme, and, not least, their reading audiences. At the beginning of *Naked City,* Weegee reminds us of this last point of intersection. The first chapter, "Sunday Morning in Manhattan," opens with a photograph of newspapers out beside a predawn city street (figure 6). Weegee describes the scene as follows:

The Sunday papers, all bundled up, are thrown on the sidewalk in front of the still-closed candy stores and newspaper stands. New Yorkers like their Sunday papers, especially the lonely men and women who live in furnished rooms. They leave early to get the papers . . . They get two. One of the standard-size papers, either the *Times* or *Tribune* . . . they're thick and heavy, plenty of reading in them, and then also the tabloid *Mirror* . . . to read Winchell and learn all about Cafe Society and the Broadway playboys and their Glamour Girl Friends.[23]

Even as he frames the scene of newspaper reading as one of pathos and isolation, Weegee makes it clear that those "lonely men and women who live in furnished rooms" are buying both the *Times* and the *Daily Mirror,* the "thick and heavy" broadside as well as the lighter (in both senses of the word) tabloid. As the photo historian Colin Westerbeck has noted, Weegee himself "lived alone in a furnished room" and likely identified with the solitary newspaper readers he described in *Naked City.*[24]

Throughout his career, Weegee openly and often humorously acknowledged the commercial imperatives of his photography. In a picture from 1939 first published in *Good Photography* magazine and later reprinted in *Naked City,* he presents what would seem to be an object of negligible visual interest: the printed receipt for a payment from Time, Incorporated (figure 7).[25] Although the statement documents a check for $35.00, the "explanation" for that payment

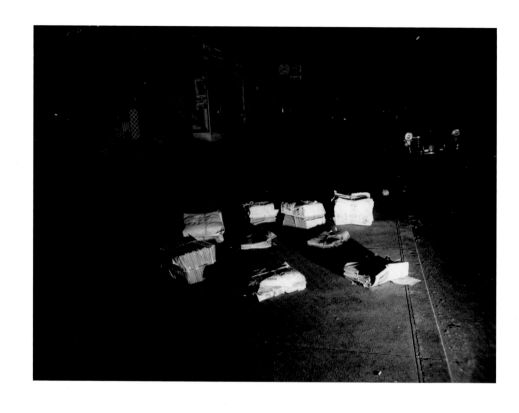

Figure 6 Weegee (Arthur Fellig), "Sunday Morning in Manhattan," n.d. From *Naked City*, 15.
© Weegee/International Center of Photography/Getty Images.

is given as "Two Murders," as though Weegee had been paid for the commission of the crimes rather than their pictorial documentation. Here, the shooting of the photograph shades into the shooting of the murder victim as the cost of life (as calculated by Time, Inc.) is rendered in brute monetary terms. The murders are noted but not shown in Weegee's photograph; what is shown is the economic transaction between freelance photographer and magazine publisher that typically remains unseen by the public. Describing this photograph in his autobiography, Weegee would write, "A check from *Life:* Two murders, thirty-five dollars. *Life* magazine pays five dollars a bullet. One stiff had five bullets in him, and the other had two."[26] Once again, the slippage from photographic representation to physical reality—from shooting pictures of gangsters to shooting bullets into them—organizes the logic of Weegee's commentary.[27] Although it is doubtful that *Life* ever employed such a pay scale as "five dollars a bullet," Weegee casts the publication as prorating—and in a sense promoting—the gun violence it seems simply to report. At the same time, Weegee admits his own participation in the market for murder photographs. The check for $35.00 from Time, Inc., was, after all, made out to him.

Weegee sought to sell his photographs to the widest possible range of newspapers and magazines, but he was rebuffed by the most established broadsides, the *New York Times* and the *Herald Tribune*. In his autobiography, Weegee attributed these rejections to class snobbery and editorial stodginess: "I couldn't get into the *Herald Tribune* because I wore no tie. I didn't bother with the *New York Times* either; I disagreed with their editorial policy of not running pictures of local dead gangsters, no matter how prominent. I just couldn't see eye to eye with them."[28] Weegee characteristically aligns himself with the tabloid appeal of vice and criminality ("pictures of local dead gangsters") rather than with the gentility of men in ties.

Those newspapers that did publish Weegee's work in the mid- to late 1930s—the *Post*, the *Daily News*, the *Mirror*, the *Journal American*, and the *World Telegram*, among others—typically did so without crediting him by name. Frustrated by his position as what he called "Mr. Anonymous," Weegee

PLEASE DETACH STATEMENT BEFORE DEPOSITING CHECK
AND RETAIN FOR YOUR RECORD

TIME, INCORPORATED NEW YORK, NEW YORK

TENDERS ATTACHED CHECK IN FULL SETTLEMENT OF ITEMS LISTED BELOW

EXPLANATION	DATE	AMOUNT	DISCOUNT	TOTAL
TWO MURDERS		35.00		35.00

Figure 7 Weegee (Arthur Fellig), *Check for Two Murders,* ca. 1939. © Weegee/International Center of Photography/Getty Images.

battled with editors and photo agencies for an individual credit line. Even when he succeeded in securing attribution, however, it was often short-lived. One edition of a daily paper might, he would ruefully recall, "give me a credit line, 'Photo by Weegee,' but in the next edition it was changed to 'Acme' again."[29]

In a 1943 article penned for the trade magazine *U.S. Camera,* Weegee advised would-be freelancers: "Once the picture has been sold—insist on a credit line. It is the photographer's display card and very important. The piling up of credit lines, in various publications, is the photographer's means of building a reputation."[30] By the time Weegee wrote these words, he was no longer "Mr. Anonymous." In 1940, the photographer began selling pictures to *PM,* the progressive newspaper launched that same year. Tabloid in format but nonsensational in content, *PM* covered national politics and world news far more extensively than the other New York tabloids. Alone among the major newspapers in New York (whether tabloid or broadside), *PM* refused to sell advertising space for fear that doing so would compromise its editorial independence. A self-described "experiment in journalism," the paper appealed to Weegee less for its left-wing, pro-Roosevelt politics than for the photographic credit and creative freedom it granted. *PM* guaranteed Weegee not only a line credit for every photograph by him that appeared in the paper but also the opportunity to write his own captions and, at times, the accompanying articles as well.

Throughout the 1940s, Weegee positioned himself as an increasingly central character in the photographs and stories he contributed to *PM.* His articles focused on the act of picture taking nearly as much as on the people and events pictured. Consider some of the headlines to his feature stories at the time: "Weegee Passes Up a Movie for a Holdup Alarm . . . And Gets This Group Portrait of Five Prisoners," "Weegee Covers Christmas in New York," "Weegee Covers Society," "Weegee Covers a Waterfront Shooting," "Weegee Photographs Society at the Waldorf," "Weegee Meets Interesting People at 6 A.M. Sunday Fire." To a degree unprecedented for a freelance photographer at the time, Weegee drew attention to the behind-the-scenes drama of

photography—a drama in which he was, of course, the star. Although he would later instruct aspiring photographers that "it is the picture that counts, not you!"[31] Weegee's own pictures, captions, and stories tirelessly showcased their creator.

A 1943 feature story in *PM* embodies this self-reflexive tendency in particularly flamboyant fashion. "Weegee, as Clown, Covers Circus from the Inside" narrates the photographer's one-night-only performance in the Ringling Brothers Circus in Madison Square Garden (figure 8). In the article, Weegee claims that his clown show was prompted by the difficulty he faced in securing candid photographs of strangers:

It's hard to photograph people & get natural expressions. The minute they see the camera, they "FREEZE" up on you. On different stories I've tried concealed & candid cameras & even infra-red invisible light. But the results were far from satisfactory. So this time . . . I decided to make my camera so obvious that the spectators wouldn't believe they were being photographed.

So I disguised myself as a clown, and went all over the Garden photographing people. They paid no attention to my camera. Thinking it was part of my clown act.[32]

Never mind that candid shots of people on the street, in bars, and at crime scenes were Weegee's stock-in-trade. Never mind that the Ringling Brothers Circus might not seem the ideal venue at which to capture "natural expressions." Weegee needed a rationale for his clown show, and the logistical challenge of candid photography furnished it.

The published article appeared as a two-page spread in *PM*. On the left page, three large photographs credited to Weegee show him preparing for and performing at the Garden. We see the photographer putting on his costume backstage (while smoking what the caption calls "his inevitable cigar") and then in full grease paint, white beanie, and flouncy clown suit. Almost nothing of the circus itself or the other performers is shown save for one backstage photograph of Weegee with a female tumbler in the midst of a handstand. Weegee stands directly beside his inverted companion and gazes down upon her sleek

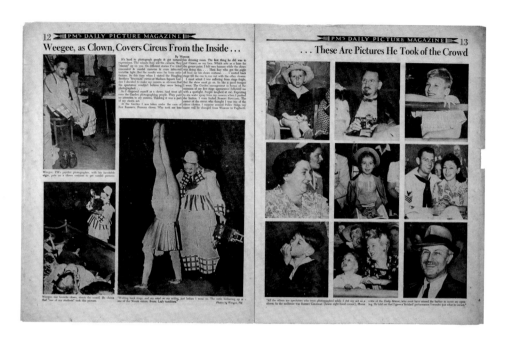

form. In the accompanying caption, he describes the scene, somewhat im-probably, as candid rather than choreographed: "Waiting back stage, and my mind on my acting, just before I went on. The cutie limbering up is one of the Novak sisters, Boots. Lady Tumblers."[33]

On the opposite page, nine smaller photographs appear in a grid under the headline ". . . These Are Pictures He Took of the Crowd." The shots of audi-ence members—several of children and adults grinning, one of a handsome sailor and his date holding hands while looking directly back at the camera—are occasionally charming but not especially candid or revealing. Our interest is drawn less to the individual portraits by Weegee than to the comical decep-tion that gave rise to them. Weegee's carnivalesque performance of photogra-phy transforms into a real one as the clown with a camera on the left-hand page delivers the grid of portraits on the right. The visual and narrative logic of the spread continually draws us back to the entertaining act of photography.

With this example in mind, we may begin to see how Fellig performed, nar-rated, and photographed the character of "Weegee" across a series of news-paper articles and magazine feature stories beginning in the late 1930s. The character could take on any number of guises—circus clown, curious passerby, mobster confidant, stumblebum at the Waldorf, police insider—while ulti-mately remaining identifiable to the reader as Weegee. Having fought to se-cure line credit for his freelance photographs in the 1930s, Fellig proceeded to insert himself ever more centrally into his pictures of the 1940s. Fellig's pho-tographs of New York City life of the period are inextricable from his skill at promoting and portraying himself as Weegee. This is not to detract from the visual immediacy and compositional inventiveness of the pictures. Rather, it is to acknowledge that Weegee's achievement as a photographer was shot through and through with the irresistibly hard-boiled character he created.

FELLIG USED HIS FIRST one-man show, in 1941 at the New York Photo League, to introduce the new character of Weegee to a new audience (figure 9).

Titled Murder is My Business, the exhibit presented a series of photographs, newspaper tear sheets, and paper cutouts tacked or pasted onto large white display boards. Unmatted and unframed, the photographs were thematically grouped under headings such as "Murder," "More Murders," "Ship Afire," "Society," "Wrecks," and "Coney Island." The effect was not unlike the galleys of a book or the mock-ups for a series of true-crime magazine spreads still in the process of being laid out. Many of the prints were so hastily affixed to their backings that they peeled slightly forward and cast shadows onto the display boards. Printed in different sizes, the photographs were sometimes packed nearly edge to edge, sometimes separated by small intervals of blank space. Paper cutouts of illustrated images (a handgun bleeding ink, a miniature Weegee with his camera) punctuated the exhibition, furthering its association with the throwaway culture of cartoons, graphics, and tabloid photography.

Within the context of Murder is My Business, Weegee's photographs were displayed not as aesthetically achieved or carefully crafted prints but as action-packed scenes of contemporary city life. A period shot of the exhibition taken by Weegee shows a trio of attentive viewers studying the murder photographs, including one man who unself-consciously rests his hand against the surface of a print (see figure 1). The viewers stand close (too close, by today's standards) to the photographs. In another from the same series of installation photographs, Weegee himself applies printer's ink to a photograph so as to touch up (and, no doubt, to draw out) the bloodstains on a shooting victim's shirt (figure 10). Weegee records, rather than conceals, his retouching of the print. As he would do throughout his career, Weegee reveled in the artifice of his own photographic practice.

In contrast to the League's commitment to photography as both a fine art and a means of social reform, Weegee presented his paste-ups as lurid montages of urban vice and sensation. Weegee heightened the effect of a show still in the process of formation by designating a single signboard for use in the immediate future: "This Space Reserved for the Latest Murders" (figure 11). Like

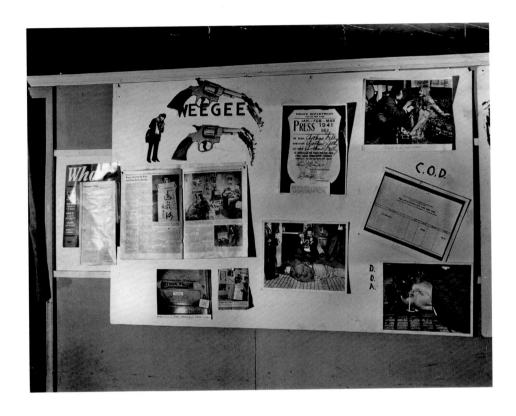

Figure 9 Weegee (Arthur Fellig), Installation view of Murder is My Business, Weegee exhibition at the Photo League, New York, 1941. © Weegee/International Center of Photography/ Getty Images.

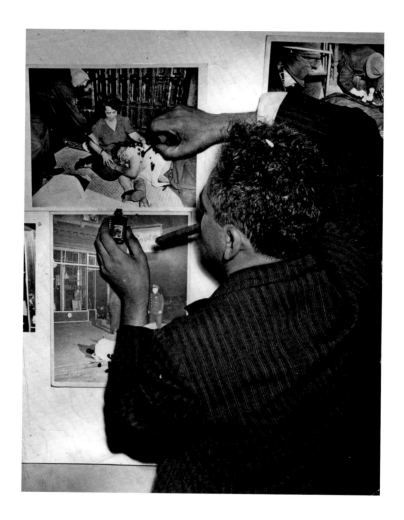

Figure 10 Unidentified photographer, Weegee applying ink to a photograph in Murder is My Business exhibition at the Photo League, New York, 1941. © Weegee/International Center of Photography/Getty Images.

the daily newspapers for which Weegee's pictures were made, Murder is My Business promised to keep its audience up to date with the most recent crimes and corpses.

That "This Space Reserved for the Latest Murders" was posted immediately beside the display board labeled "Society" suggests both the wide range of Weegee's photographic subjects ("from debutante balls to hatchet murders," as he put it in 1937)[34] and the tabloid logic that linked these seemingly disjunct worlds. It was not the charity balls or opera premieres in and of themselves but Weegee's unlikely presence at them that provided the hook as well as the headline for the stories he wrote about elite culture in *PM*. Consider, in this regard, the two-page spread posted in the center of the "Society" display board, "Weegee Photographs Society at the Waldorf" (figure 12). Written by Weegee, the article opens as follows: "Why, I don't know, but I was assigned to cover the Cinderella Ball. Go get plenty of fashion pictures was the editor's parting shot."[35] However, the story's lead photograph is not of a fashion plate but of a bottle of champagne. Its caption, written by (who else?) Weegee, reads "Champagne was $10 a bottle. I like rye with a beer chaser."[36]

Running throughout Weegee's coverage of the upper classes in *PM* was a satirical refrain about the distance between himself—the street-toughened, sleep-deprived crime photographer—and the effete, elite precincts of champagne society. A copy of *PM* in 1940 cost a nickel, whereas a bottle of champagne at the Waldorf would, as Weegee reports, set you back ten dollars. By contrasting his humble taste with the excesses and finery of high society, Weegee simultaneously inserted himself into the story and aligned himself with the working-class readers that *PM* was most directly addressing.

Take, for another example, the photograph of four men in top hats that appears on the right edge of the "Society" display board (figure 13). For its display in Murder is My Business, Weegee inked a caption, "High Hatted Hitch Hikers," directly on the print. The caption refers, tongue in cheek, to the fact that the four gentlemen are waiting for their limousine drivers to pull up to the curb. The photograph originally appeared, in a tightly cropped version, on

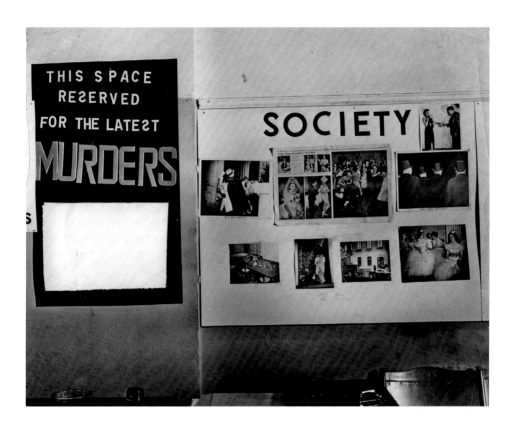

Figure 11 Weegee (Arthur Fellig), Installation view of Murder is My Business, Weegee exhibition at the Photo League, New York, 1941. © Weegee/International Center of Photography/ Getty Images.

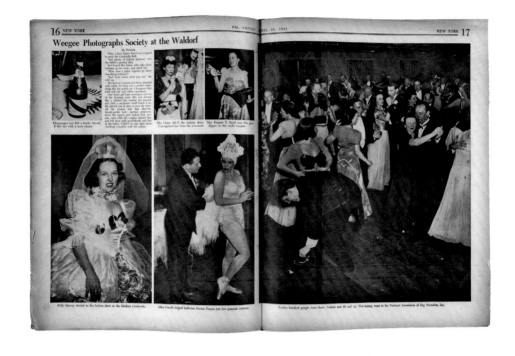

the front page of *PM* in 1940. In that context, its caption announced, "The Opera Opened Last Night. Weegee made this picture. He tells how on Page 2." And here, according to Weegee, is how:

Last night at the opening of the Metropolitan Opera season, I rubbed elbows and stepped on the toes of the society crowd . . . On the outside of the opera house on W. 39th Street, after the performance, between the mink coats and the high hats, I felt like an Italian in Greek territory. Without a high hat the cops showed you across the street, they gave me dirty looks but I was saved by my press card. The jam was terrific. All the high hats were looking for their limousines. It was a battle of the minks and the fur flew . . . The women were young and oh so beautiful and the men were elderly. I think most of the limousines were rented for the occasion. They had that funeral look.[37]

Note Weegee's use of the term "high hats" rather than the more colloquial "top hats" to underscore the haughtiness of the well-heeled gentlemen. Weegee strikes a lightly adversarial attitude toward not only the "mink coats and high hats" of the "society crowd" but also the "cops" who shoot him "dirty looks." Once again, the photographer becomes part of the story rather than simply illustrating it. The story is one of class division and the passport that photo-journalism provides ("I was saved by my press card") to otherwise restricted spheres of contemporary city life.

Immediately following the run of Murder is My Business, the Photo League sponsored a second version of the show featuring additional photographs and display boards. By way of explanation, Weegee posted a signboard: "Due to an increase in murders, The Photo League presents 2nd Edition Murder is My Business by Weegee." The word "edition" comes as something of a surprise here, insofar as it typically is applied to the printing of a book or a daily newspaper (in morning, afternoon, or late editions) rather than to the remounting of an exhibition. The term makes sense, however, insofar as Weegee was presenting a mock-up of his work as a press photographer to date. The second edition of Murder is My Business, overlapping with but distinct from the first, was not unlike a newspaper or book that had gone back to print.

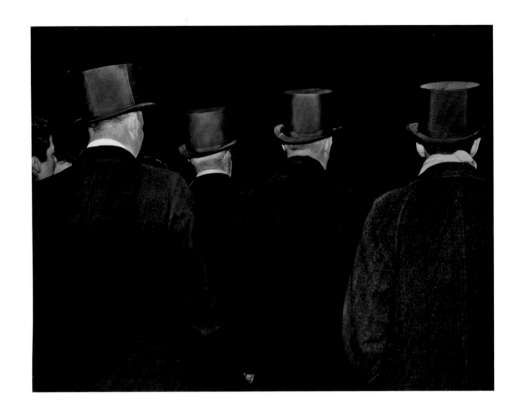

Figure 13 Weegee (Arthur Fellig), *The four High Hats are waiting for James and the Limousine,* 1940. © Weegee/International Center of Photography/Getty Images.

Far from concealing the tabloid context of his work, Weegee displayed several tear sheets from *PM* and at least one clipping from the *Daily News* in the show. The first signboard in the exhibition was crowned by a small caricature of the photographer with camera in hand (see figure 9) beside cutout letters announcing "Introducing Weegee." The board included a two-page article from *PM* titled "Weegee Lives for His Work and Thinks Before Shooting." Like the *Life* and *Popular Photography* profiles, the *PM* story told of Weegee's wifeless existence as a crime photographer living in a one-room flat across from police headquarters. It presented the photographer as casually indifferent to the storage and preservation of his work: "Weegee has taken thousands of pictures and he has thrown away tons of prints. He has no filing system and says he doesn't need one. Most of his pictures are spot news, and therefore, if they're ever used, they're used right away."[38] It was the relentless production of images, rather than the isolation of any one pictorial moment or masterwork, that constituted Weegee's "business" as a photojournalist, a business in which photographs, like murders, were seen as largely interchangeable. He created pictures for immediate sale and reproduction rather than unique prints to be saved for posterity.

At Weegee's Photo League exhibition, as on the walls of his apartment, no photographic print or newspaper tear sheet could be seen in isolation from its unruly neighbors. The individual picture could be understood only as part of an ongoing, New York story of murder, disaster, society, and sensation. With its vernacular title and visual excess, Murder is My Business presented photography neither as fine art nor as a tool of social justice. Rather, it inserted the visual logic of the tabloid into the galleries of the Photo League.

IN 1945, WEEGEE'S *NAKED CITY* became both a popular and critical success. The book was praised by many publications, including the *New York Times* ("excellent pictures of Manhattan scenes"), the *Saturday Review of Literature* ("a wise and wonderful book"), *Time* ("a first-rate reporter's picture of Manhattan"), *Newsweek* ("Weegee today is Art") and the *Washington Post* ("a book

to cherish, and re-explore, and promote among your friends").[39] As Miles Orvell has noted, the *New York Times* review "reproduced as 'art' three photographs it wouldn't have printed as 'news.' "[40]

Orvell's comment reminds us of the surprising degree to which *Naked City* was received as art rather than journalism or popular photography. From the moment of its initial publication, *Naked City* was marketed to multiple, though not mutually exclusive, audiences. The book appeared in two different versions: a $4.00 cloth edition with gravure reproductions published by Essential Books and an abridged pulp paperback from Zebra Picture Books that sold for 25 cents a copy. Where the cover of the pulp paperback presents a single, iconic Weegee image (a photo of the murdered gangster Andrew Izzo that first appeared in a 1942 issue of *PM*), the cover of the cloth edition represents *Naked City* through a montage of sorts. Each letter in the book's title has been filled with a detail from a different photograph—a burning building, the crowd at Coney Island, a suicide attempt, a cop saving kittens, and so on. The cover of the cloth edition captures the multiplicity of Weegee's photojournalism while organizing it into a coherent, quasi-Constructivist design.

The cloth volume also features an endorsement from Nancy Newhall, acting curator of photography (while her husband, Beaumont, was fighting in the war) at the Museum of Modern Art. "Through his sense of timing, Weegee turns the commonplaces of a great city into extraordinary psychological documents." The blurb on the pulp paperback, by contrast, quotes *Time* magazine: "Weegee photographs that O. Henry might have done if he worked with a camera" (in true pulp fashion, it botches the grammar of its source quotation).[41] *Naked City* aimed to appeal both to a museum-going audience—or, at least, to an audience impressed by the approval of a museum curator—and to a populist, "rye with a beer chaser" readership.

The claim for Weegee as a fine artist is made explicit in the foreword to the cloth edition of the book (the paperback includes no such introduction). *PM*'s editor, William McCleery, analogizes Weegee's relationship to New York as

that of groom to bride. The extremes to which McCleery takes the marital metaphor perhaps reveal the limits of its applicability: "Loving the city, Weegee has been able to live with her in the utmost intimacy. . . . In sickness and in health he will take his camera and ride off in search of new evidence that his city, even in her most drunken and disorderly and pathetic moments, is beautiful. Of course Weegee, being an Artist, has his own conception of what constitutes beauty, and in some cases it is hard for us to share his conception; but insofar as we can share it, we share his love for the city."[42] McCleery's prose seems particularly overblown here, not least in the grandiose gesture of declaring Weegee a capital *a* "Artist."

In a review for *PM,* the modernist photographer Paul Strand praised Weegee's book as "the first major contribution of day-to-day journalism to photography as a creative medium." To bolster this claim, Strand applied an idealist rhetoric of truth and dignity to *Naked City:* "There is much in the subject matter of this book which is sensational. But sensationalism is not Weegee's purpose. He is an artist, a man of serious and strong feeling. In the area of life in which he has lived and worked, his photographs truly record the way he sees. To this reviewer they are an extraordinary amalgam of sardonic humor, resentment of injustice, pathos, and compassion tinged with bitterness. They seem to say, over and over again, 'Life should have some dignity.' "[43]

Such refined language strikes a jarring note in relation to the tabloid pictures and rat-a-tat text of *Naked City.* Among the many messages the book might be said to impart, "Life should have some dignity" hardly ranks near the top. Weegee's own encapsulations of city life ("People get bumped off . . . on the sidewalks of New York" or "The cop got a medal . . . the gunman got the bullets") seem far more apt.[44]

Part of what claims for beauty, truth, and dignity miss about *Naked City* is the centrality to the book's success of tricks, puns, and sleights of hand: the pairing, for example, of a photograph of children straining to get a look at a dead body ("Their First Murder") with a facing-page picture of a corpse from

an entirely different murder scene (figure 14); or the use of infrared film to spy on lovers at night on the beach at Coney Island; or the picture, captioned "A New Low in Arrests," of a dwarf in police custody (168).

Near the beginning of *Naked City* Weegee asserts, "The people in these photographs are real. Some from the East Side and Harlem tenements, others are from Park Avenue" (11–12). Yet the "reality" of the people portrayed is repeatedly undermined as they are cut loose from their original contexts and repositioned in a story, loosely organized by theme, about the dangers and occasional pleasures of city life. The chapter headings—"Fires," "Murders," "The Bowery," "Harlem," "The Curious Ones," "The Escapists"—locate the people in *Naked City* as representatives of events, neighborhoods, or collective patterns of behavior. The book assigns no dates to its 227 photographs, nor does it name the figures who appear in them, save for the occasional celebrity whether national ("Frankie" Sinatra) or local ("Norma, the star of Sammy's Foolish Frolics" on the Bowery).

The book unfolds in the present tense or in an undifferentiated recent past that lies beyond the bounds of specific identities, lives, and losses. At times, the narrative assumes the form of an urban fable: "Chapter 5: Sudden Death" begins "It's a lovely evening ... the full moon is out. A car somehow or other drives off a pier into the river. The couples in the parked cars in 'Lovers' Lane,' as the pier is called, run out of the cars dressed in pajamas" (88). Elsewhere Weegee writes, "Night ... a black velvet curtain has dropped over a white sky ... a few mothers went looking for their kids ..." (37).

Naked City ends not with a dramatic climax or narrative resolution but with a series of tips for the would-be press photographer, from recommendations about camera lenses and f-stops to advice about potential hazards on the job ("at fires, be careful not to trip over hose lines strung along the streets," 241; "and at auto accidents where gasoline is spilled all over the streets, don't light a smoke," 241). Some of the tips are lifted, almost verbatim, from Weegee's earlier articles and profiles. The instruction "Think before you shoot ... get punch into your pictures" (214), for example, combines the titles of Ralph Steiner's

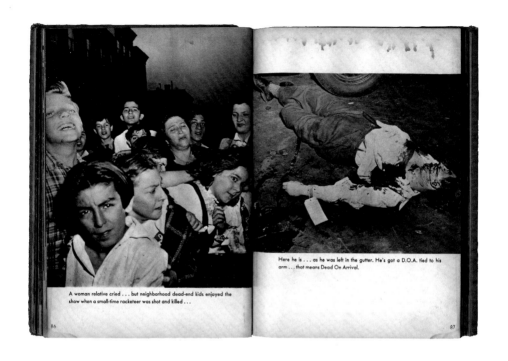

A woman relative cried . . . but neighborhood dead-end kids enjoyed the show when a small-time racketeer was shot and killed . . .

Here he is . . . as he was left in the gutter. He's got a D.O.A. tied to his arm . . . that means Dead On Arrival.

86

87

Figure 14 Weegee (Arthur Fellig), "A woman relative cried . . ." and "Here he is . . ." From *Naked City*, 86-87. © Weegee/International Center of Photography/Getty Images.

1941 *PM* article, "Weegee Lives for His Work and Thinks Before Shooting," and a 1943 feature by Weegee in *U.S. Camera*, "Punch in Pictures." In sharp contrast to *Naked City*'s florid introduction by McCleery, Weegee's final words are technical and instructive. He offers advice to the aspiring photojournalist, not to the aspiring artist.

THE PUBLICATION OF *NAKED CITY* marked both the apogee and the end point of Weegee's career as a press photographer. The success of the book freed him from the confines of tabloid culture, from "murder as his business." In 1946, he would announce that he was moving on to other pictorial subjects and pursuits:

> After my first book, *Naked City*, had run into three editions within a few months, I found myself in a confident and happy mood. And the way I feel—well, that's the way I take pictures, so I parked my car and cut the wires of the police radio set in it. I was through with the newspaper game—through with chasing ambulances to scenes of crime and horror—I was saturated with the tears of women and with children sleeping on fire escapes. Now I could really photograph the subjects I liked—I was free.[45]

Weegee's newfound "freedom" inspired him to work briefly for *Vogue* magazine, to consult on movie and television projects in Los Angeles (including a 1948 film version of *Naked City*), to appear as a bit player in several Hollywood films, to author additional photo-books (e.g., *Weegee's People, Naked Hollywood*) and how-to manuals (*Weegee's Secrets of Shooting with Photoflash*), and to shoot pictures of celebrities, nudists, and burlesque queens. None of these endeavors equaled—or even approached—the success of *Naked City*.

Throughout the 1950s, Weegee created a series of self-consciously "artistic" photographs by using prismatic lenses and kaleidoscopic effects to distort the surface of the image. It was as though he had transposed the earlier manipulations of his tabloid pictures onto the plane of photographic form (figures 15 and 16). Instead of placing a steering wheel in the hands of a car crash victim or inducing a man to reenact his escape from a tenement fire (as he had done

in the 1930s and '40s), Weegee now used optical devices and trick lenses to distort the pictorial composition from within. By stretching the female nude like taffy or bending the celebrated face of Pablo Picasso or Marilyn Monroe into a visual grotesque, Weegee thought he was creating art. But to the contrary, his distortion photographs were (and are) largely dismissed as inferior, gimmicky, even embarrassing.[46] The greatest irony: Weegee's self-professed "art" photographs have been demoted to the status of kitsch while his tabloid pictures have been elevated to the realm of high art.

When seen as art, Weegee's news photographs of the 1930s and '40s are typically redefined as a series of freestanding works or vintage prints. In an influential 1977 monograph, Weegee's friend and fellow photographer Louis Stettner argued that "most of Weegee's photographs were taken as single accomplishments and were meant to be viewed independently of other photographs."[47] Yet we only have to consult the newspapers and magazines in which many of those photographs first appeared to see that they were meant to be viewed cheek by jowl, alongside other pictures, headlines, captions, and stories. The art-historical scholarship on Weegee has kept a polite distance from those newspapers and magazines. No pages from *PM* or layouts from *Life* are reproduced in the exhibition catalogs or critical surveys to date.

In 2004 the Ubu Gallery in New York printed a mock-tabloid with the front-page headline "Weegee's Story" above a picture of two men in a paddy wagon using their top hats to hide their faces from the camera.[48] The gallery's handout provided a means of publicizing its exhibition of "more than 220 rare vintage photos" by Weegee (figure 17). The tabloid resurfaces here less as a historically specific context for Weegee's photographs than as a clever tool for marketing them to contemporary collectors.

The tension between fine art and tabloid journalism, between those "rare vintage photos" and the inexpensive newspapers for which they were intended, runs throughout the critical literature on and curatorial displays of Weegee's work. According to Stettner, for example, "Weegee's best works are, in essence, news photographs whose profundity and significance have lifted

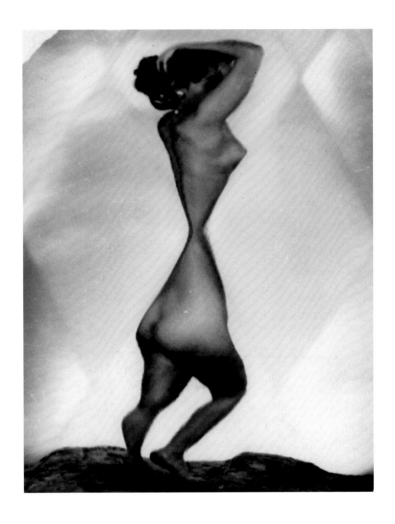

Figure 15 Weegee (Arthur Fellig), *Nude*, ca. 1953–56. © Weegee/International Center of Photography/Getty Images.

Figure 16 Weegee (Arthur Fellig), *Pablo Picasso*, ca. 1960. © Weegee/International Center of Photography/Getty Images.

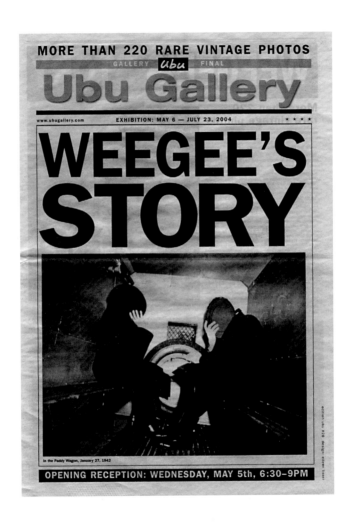

Figure 17 "Ubu Gallery: Weegee's Story," 2004. Ubu Gallery, New York and Galerie Berinson, Berlin / Design: Eileen Boxer, BoxerDesign.

them up into the realm of art."[49] Reviewing Weegee's first museum retrospective at the International Center of Photography (for which Stettner's book served as companion), Ben Lifson similarly argued that a "singularly striking photograph" such as *Gun Shop* (in which a giant replica of a handgun hovers over a city street) "suggests that Weegee had it in him to escape the world of news and explore an art of self-selected imagery that he could have moved beyond the rhetoric of journalism."[50] The assumption behind such claims is that while singularly striking photographs and "best works" may be elevated above their lowly origins in the picture press, the origins themselves remain of little interest.

In a bracing review of the same ICP retrospective, the critic Gene Thornton noted: "It is always faintly alarming to see the photographs of Weegee on exhibition at a museum or gallery. They were not made for exhibition but to be produced in tabloid newspapers, and a 'vintage' Weegee print is usually a hastily printed glossy, crumpled and dog-eared from hard usage in newspaper offices and pressrooms. The current retrospective exhibition of 103 Weegee photographs at the ICP . . . is largely composed of vintage prints and it is strange to see so many refugees from the picture files matted and framed like precious Rembrandt etchings."[51]

As Weegee's photographs are detached from their original context, the specificity of the people and events they portray becomes similarly obscured. Individual murder victims, suspects, and witnesses in once-current New York City crime scenes become characters in an imagined narrative, much as Weegee himself emerges as a hard-boiled detective-narrator, a shutterbug Sam Spade or Mike Hammer.[52] The appeal of film noir and the midcentury detective story remains so strong that we have forcibly to remind ourselves that real, rather than fictional, deaths and disasters are recorded in Weegee's photographs. His pictures are now printed—full-bleed, of course—on the covers of crime novels and compendia as well as of art monographs. A photograph titled *Corpse with Revolver,* for example, invites readers into the pages of both a 1985 reprint of *The Five Great Novels of James M. Cain* and a 2002 edition of

Illustrated True Crime (figures 18 and 19). The same picture appears on the cover of the 1982 monograph *Weegee's New York.*

GIVEN SUCH ADAPTABILITY, how are we to peel back the layers of fictionalized narrative and noir nostalgia that have accumulated on Weegee's photographs to recover the commercial and historical conditions under which they were taken? In the case of *Corpse with Revolver,* we can supply a name and narrative to the man in the photograph. Yet, as we will see, the narrative obscures as much it clarifies about the picture.

On August 7, 1936 (just two days after the trunk murder story broke), the *New York Post* reported on another gang-related killing. In this case, "Dominick Didato, alias Terry Burns, racketeering gambler who was a reputed gang foe of Charles (Lucky) Luciano . . . was shot to death early outside a lower East Side restaurant. His murder, in an intricate criss-cross of gang relationships, is linked with the gang killings of three other New York racketeers within the past ten days."[53] The story was illustrated by a photograph (credited simply to "Post Photo") of Didato's corpse accompanied not only by his hat and revolver but also by a group of police officers and medics. "It's Bad Luck to Chisel In on Lucky" warned the *Post*'s cheeky overline to the picture.

The photograph published in the *Post* is not the same picture as *Corpse with Revolver.*[54] The former was likely shot not by Weegee but by another freelance or staff photographer (no matching print or negative for the photograph survives in the extensive Weegee archives at the ICP). The *Post* photograph shows the corpse laid out with its feet toward the camera, whereas Weegee frames the corpse head, or rather hat, first. Both shots present Didato at an oblique angle to the picture plane, but the *Post* version has the corpse surrounded by a semicircle of onlookers, while Weegee composes a "still life" of corpse, revolver, and fedora on a blood-puddled pavement.[55]

Although it was intended for sale to a daily newspaper, *Corpse with Revolver* was not published in 1936. It is among the hundreds of news photographs shot by Weegee in the 1930s and early '40s that surfaced only in later decades, when

his work had become of interest for other reasons, whether as art, popular il-
lustration, or crime reportage. In 1953, nearly twenty years after the murder
of Dominick Didato, *Corpse with Revolver* was published as the lead photo-
graph for a "true crime" story in the pulp magazine *Photo.* In the early 1950s,
Weegee frequently contributed pictures—and sometimes entire photo-essays
and articles—to magazines such as *Photo, Photographer's Showcase,* and *Art Pho-
tography* that used the alibi of artistic photography and vocational instruction
to peddle pictures of buxom young women and, to a lesser extent, true crime
and novelty photographs. During this same time, Weegee also sold photographs
to soft-core "men's magazines" such as *Hi Ho!* and *Swank* that generally of-
fered their pinups without much in the way of educational excuse or artistic
justification. He contributed, for example, both text and pictures for "House
of 1,000 Girls," a feature in the January 1950 issue of *Stag,* and three "Nudes
by Weegee" appeared in the May 1954 issue of the recently launched *Playboy*
magazine. In both the photo pulps and the men's magazines, Weegee alter-
nately recycled his pre-1945 crime photographs and published more recent
shots of celebrities, nudists, and burlesque queens.[56]

In the August 1953 issue of *Photo, Corpse with Revolver* appears opposite a
photograph of one Linda Lombard posing in a striped bikini on the beach
(figure 20). With her spread-legged, nearly calisthenic pose, Lombard domi-
nates the low horizon line and white background of the picture. Her physical
energy and slightly deranged sunniness provide an oddly effective counter-
part to Weegee's shadowy picture of the newly dead body of Dominick Didato.
Corpse with Revolver introduces an article not by Weegee but by a fellow crime
reporter with the unlikely name of Ginger Ungemacht. In "I Covered a Gang
War," Ungemacht recounts a 1934 confrontation between the mobsters Dutch
Schultz and "Mad Dog" Coll. The "gang war" at issue has nothing to do with
the murder recorded in Weegee's picture.[57] Dominick Didato's name, in fact,
is never mentioned in the article.

Once it is no longer an account of a particular crime scene or murder vic-
tim, *Corpse with Revolver* may be slotted into any number of different contexts,

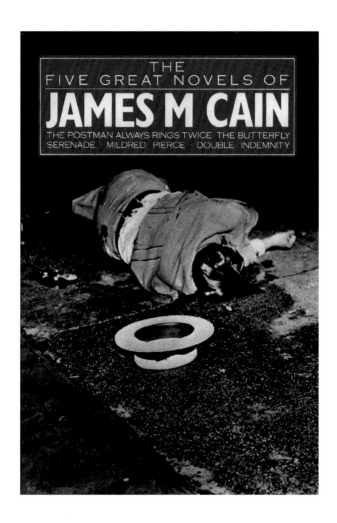

Figure 18 Cover, *Five Great Novels of James M. Cain*, 1985.

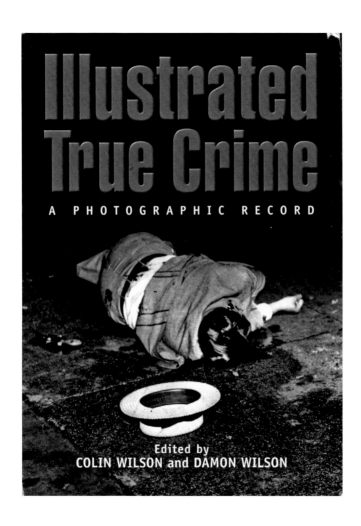

Figure 19 Cover, *Illustrated True Crime: A Photographic Record*, 2002.

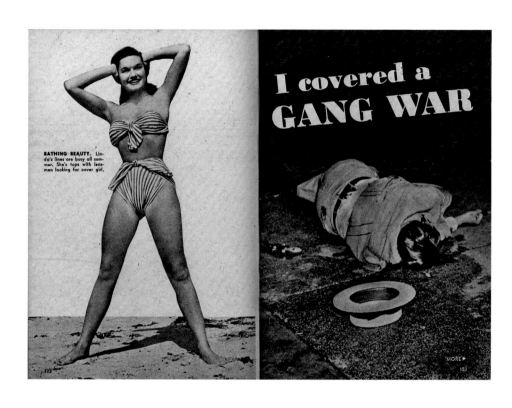

Figure 20 "Bathing Beauty" and "I Covered a Gang War," in *Photo*, 1953, 122-23.

whether it be the quasi-fictional recounting of a gang war in a pulp magazine, a reprint of five midcentury detective novels, or a visual compendium of "true crime" throughout the twentieth century. From the start of his career, Weegee played an active role in the recycling, recaptioning, and resignification of his own photographs. Recall, for example, how quickly the trunk murder photograph moved from the news pages of the *New York Post* to the "Speaking of Pictures" column in *Life* magazine. With *Naked City,* Weegee extended and expanded on the inherent adaptability of his photographs.

Even when he did not literally reprint an old picture, Weegee recycled his crime photographs by other means. In 1946, almost ten years after his first appearance in *Life* magazine, Weegee was again featured in the "Speaking of Pictures" section. This time it was for a photo-essay titled "Weegee Shows How to Photograph a Corpse."[58] Using a plastic dummy, Weegee instructed a group of Chicago design students on how to approach a dead body for maximum photographic effect. The scene, as staged by the photographer, included a fedora and a (fake) gun, spaced slightly to one side of the dummy. Though not yet published at the time, *Corpse with Revolver* had become Weegee's visual paradigm and pedagogical example. It was not, as the photographer told *PM* in 1941, that "all murders look pretty much the same."[59] Rather, it was that various murder scenes could be made, through the use of flash lighting, perspective, cropping, composition, and (movable?) props, to resemble a photograph by "Weegee the Famous." In "How to Photograph a Corpse," the scene of photographic instruction becomes a form of visual entertainment not only for the design students in Chicago but also, and more to the point, for the mass readership of *Life.*

In the six decades since "How to Photograph a Corpse" was published in *Life,* art museums, galleries, book publishers, and auction houses have positioned Weegee as a creative visionary whose quintessentially American pictures of the 1930s and '40s mark a signal moment in the history of photography.[60] Notwithstanding their thrillingly lowbrow appeal, Weegee's tabloid pictures have been made over into objects of aesthetic value. Photographs intended for

the *Daily News* and *PM* are now featured in beautifully printed books such as *Photographers of Genius at the Getty* and *Masterpieces of Photography: From the George Eastman House Collections.*[61]

In 2000, the Phillips auction house in New York held the first major sale devoted entirely to Weegee photographs. Lot 176 consisted of a posthumously printed portfolio of forty-nine of "Weegee's greatest and most famous images," now available in large-scale, selenium-toned, silver gelatin prints on double-weight paper. Although Weegee never worked in such a deluxe format during his lifetime, the auction catalog noted that "[a]ll of the prints are in perfect condition archivally finished and matted." Despite their having been made posthumously, they are, according to the catalog, "the most beautiful prints ever made from Weegee's negatives."[62] The winning bid for the portfolio at the Phillips sale was $63,000, slightly below the high presale estimate of $75,000 to $85,000.

No doubt Weegee would have approved of any successful approach to marketing his photographs. From the trunk murder photograph to *Corpse with Revolver,* from Murder is My Business to *Naked City,* he constantly recycled his photographs for different audiences and commercial opportunities. But in considering the "perfect" printing and archival finishing of the Phillips portfolio, we might also recall Weegee's advice to would-be freelancers in 1941: "Don't worry about secret formulas and fine grain developers, or you'll wind up being a hypo mixer, not a photographer."[63] It was the narrative content and visual punch of the picture, rather than the quality of the print or the weight of the paper, that mattered most to Weegee. By making his pictures into fine art, we lose much of what was (and remains) most compelling about them.

In his persuasive account of the dialogue between art and mass culture, Thomas Crow notes that "advanced artists repeatedly make unsettling equations between high and low which dislocate the apparently fixed terms of that hierarchy into new and persuasive configurations, thus calling it into question from within."[64] What has been less well analyzed by art historians, however, is the movement in the opposite direction, whereby visionary creators of mass

culture dislocate the hierarchy of high and low from, as it were, below.[65] How, for example, are we to trace the passage of Weegee's tabloid photography into the rarefied precincts—and prices—of high art, particularly when his more self-consciously "artistic" photography failed to secure its intended status?

By way of response, I turn to an unlikely source—Clement Greenberg, the twentieth-century critic most responsible for enforcing the modernist divide between high and low culture or, as he famously put it in 1939, between "avant-garde and kitsch." Greenberg's antipathy to the "rear-guard" of "popular, commercial art and literature, with their chromeotypes, magazine covers, illustrations, ads, slick and pulp fiction, Tin Pan Alley music, tap dancing, Hollywood movies, etc. etc.,"[66] would seem to predict a similar contempt for Weegee's brand of popular photojournalism. The art critic's later remarks about photography in general and Weegee in particular therefore come as something of a surprise.

In a 1946 review essay titled "The Camera's Glass Eye," Greenberg argued that "Unlike painting and poetry, it [photography] can put all emphasis on an explicit subject, anecdote, or message; the artist is permitted, in what is still so relatively mechanical and neutral a medium, to identify the 'human interest' of his subject as he cannot in any of the other arts without falling into banality."[67] Terms that Greenberg would elsewhere dismiss as antithetical to vanguard art—"anecdote," "message," "human interest," "explicit subject"— are here reclaimed as the special province of photography. Whereas modern painting and poetry had, in Greenberg's view, to avoid subject matter "like a plague,"[68] photography was to embrace subject matter and storytelling as its defining strengths.

Building on this premise in a later review, Greenberg wrote that "the photograph has to tell a story if it is to work as art. And it is in choosing and accosting his story, or subject, that the artist-photographer makes the decision crucial to his art. Everything else—the pictorial values and the plastic values, the composition and its accents—will more or less derive from these decisions."[69] The "artist-photographer" does not simply select a story or subject,

he "accosts" it in the manner of an aggressive reporter angling for a scoop. The story then shapes the visual form of the photograph, not the other way around. When these priorities are reversed, when photographers privilege formal values over story or subject, the result is "arty" rather than genuine art.

For Greenberg, even the beautifully composed street photographs of Henri Cartier-Bresson ("one of the best photographers of our day") sometimes lapse into artiness. The raw photojournalism of Weegee does not: "The pictorial values in the snapshots of such an unsophisticated artist as Weegee (who worked for the tabloids) cannot be compared with those in Cartier-Bresson's, but Weegee's photographs show a sharper sense of life and movement and variety. Weegee is demotic, but Cartier-Bresson is almost conventionally esoteric, and in this art the demotic eye is the one more apt to discover unexploited possibilities of 'literature.'"[70] The initial disdain of Weegee's "snapshots" is offset by the genuine vividness—the "sharper sense of life and movement and variety"—they continue to spark. At the same time, Greenberg cannot quite forgive the tabloid photographer's lack of sophistication and unlovely pictorial values. It is as though Greenberg wants Weegee's populism without the popular culture from which it springs, the "demotic" vision without the crude production values.

For all of his insistence on photography as a narrative art, Greenberg never tells us what kinds of stories he has in mind. He does not tell us, for instance, that Weegee's "possibilities of 'literature'" were trunk box murders and freak accidents, clown shows at Madison Square Garden and the crowds on Coney Island. Weegee's "explicit subjects" were lurid crimes and popular distractions, the public life of New York City as seen through the lens of pulp sensationalism. He photographed these stories not to make art but to make the next day's edition of the *New York Post* or *PM*. Greenberg therefore gets Weegee at least half wrong. By insisting that "the photograph has to tell a story if it is to work as art," Greenberg overlooks the equally relevant point that the photograph has to tell a story if it is to work as news or, for that matter, as entertainment.

This is the dirty little secret of photography as a fine art: unlike painting or

poetry or sculpture, photography can never be fully dissociated from its "low" or nonartistic uses. No degree of deluxe printing, archival matting, or selenium toning will ever remove the art photograph entirely from its more common (in both senses of the word) relations: the snapshot, the mug shot, the family portrait, the news photograph, the tabloid exposé. Greenberg recognized that the history of photography opened onto a broader social and material world, a world of stories and subjects and "human interest." But he could embrace this world only when it was elevated into art.

Like Greenberg, Weegee understood story and subject matter as crucial to the success of photography. But the pictures for which he is best remembered had little truck use for art. "News photography is my meat," he would write in *Weegee's Secrets of Shooting with Photoflash.*

I can't remember a time when I didn't have my camera by my side, on the prowl for a "scoop." I've dabbled in all sorts of photography... documentary, portrait, movie, but my first love is still following (or preceding) the police cars and fire engines. . . . All of this means that I think, essentially, in terms of news photography . . . [yet] almost all of the photo principles and rules I mention can apply equally as well to any other kind of photography... babies, parties, social gatherings, etc. After all, the qualities of dramatic interest should be part of every photograph.[71]

Weegee wrote these words in 1953, by which time he had, in fact, stopped making news photographs, prowling for scoops, and following police cars. The trick photographs and novelty nudes he was making at the time were, ironically enough, almost entirely devoid of narrative content and "dramatic interest." In an effort to make capital *a* "Art," Weegee had decided to stylize, distort, and abstract the visual form of his photographs. The results, as Greenberg might have predicted, were disastrous.

I do not believe that, as a *New York Times* reviewer put it in 1997, "Weegee's talent left him when he left Manhattan, determined to become famous in Hollywood and to gain recognition as an artist."[72] Weegee's relocation to Los Angeles in 1947 led to the loss not of his talent as a photographer but rather of the

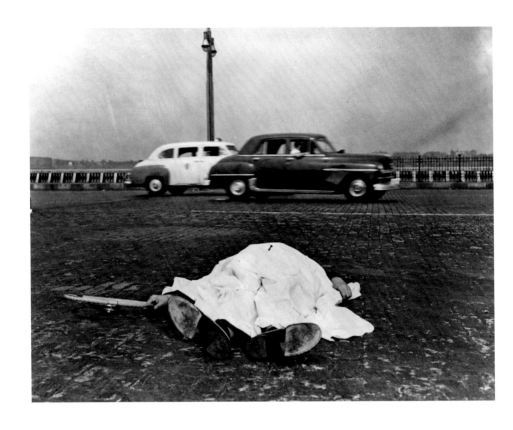

Figure 21 Weegee (Arthur Fellig), *Victim of Auto Accident*, October 29, 1939. © Weegee/International Center of Photography/Getty Images.

professional context of tabloid journalism—of "chasing ambulances to scenes of crime and horror." He left behind the sensational stories, local knowledge, and narrative intensity that rendered both the character of Weegee and his photographs compelling in the first place.

In the chapter of his autobiography titled "Crime Photographer," Weegee writes:

Being a free-lance photographer was not the easiest line of work. There had to be a good meaty story to get the editors to buy the pictures. A truck crash with the driver trapped inside, his face a crisscross of blood . . . a tenement-house fire, with the screaming people being carried down the aerial ladder clutching their babies . . . a just-shot gangster, lying in the gutter, well dressed in his dark suit and pearl hat, hot off the griddle, with a priest, who seemed to appear from nowhere, giving him last rites . . . just-caught stick-up men, lady burglars, etc.[73]

Weegee knew how to capture, compose, and, when necessary, contrive "a good meaty story" for the popular press. His pictures of lady burglars and just-shot gangsters, of truck crashes and tenement fires remain intensely affecting, even as the people in them have long since passed out of public recognition or newsworthiness (figure 21). Weegee was not a great artist or even, as his late distortions and endlessly naughty cheesecake shots attest, a great photographer. But he was a great tabloid photographer. Perhaps it is time that we reckon with his achievement on its own low terms.

Human Interest Stories

ANTHONY W. LEE

ABOUT TWO O'CLOCK in the morning on December 15, 1939, a man named Joseph Raff woke from a light sleep in his fourth-floor Brooklyn tenement to the smell of smoke. He was tempted to go back to sleep, he later said, thinking that his oil heater was acting up again and giving off that noxious burnt odor. But the smell got stronger, and looking into the darkness of his bedroom, he could see smoke billowing through the floorboards. A fire had broken out in the tenement below him, and by the time Raff had gotten to his feet, the whole building was ablaze. By then the building janitor, Harry Stera, was going floor to floor, pounding on the thin walls and doors to rouse the tenants and ushering them through the burning hallways and down the fire escapes. A passerby, a man named David Breenberg, ran up the stairs and through the narrow corridors of the tenement house, fighting the smoke and heat, looking for anyone who might be trapped. He found a fourteen-year-old girl, Clara Biderman, overcome. It was in her family's rear apartment that the fire had begun. Despite the efforts of Stera and Breenberg, it was clear that not all of the tenants had been roused in time and escaped or been helped to the streets below. A young immigrant from Puerto Rico, Ramona Malave, and her young son, Edward, were still somewhere inside. The fire chief later determined that the two had attempted without success to pry open the window of their fourth-floor apartment to call for help—it was probably

painted shut—and had fallen unconscious to the floor, where they had become asphyxiated and burned.

It was not unusual for old tenement buildings in Brooklyn and the Lower East Side to catch on fire. The combination of the tin ceilings and the wooden lath beneath the many coats of paint and plaster created a warren of tinder-boxes. The airshafts were perfect fire conductors, feeding any small spark with an updraft of oxygen and providing a ready channel for the smoke and flames to reach up through the stacked apartments. The hallways and small rooms were old and worn, as waves of families had passed through them. Most, like Ramona Malave, were immigrants; they had begun pouring into New York in the late nineteenth century and needed cheap places to live. Even in 1939, after more than a half century of hard use, the tenements overflowed with people—this one in Brooklyn housed eleven families, nearly fifty tenants in all, in eight small, two-room apartments. The absentee landlords often ignored basic maintenance, leaving pipes and wood beams exposed and stoves and heat boxes with unsealed cracks. During the cold winters, the masses of tenants tried all kinds of methods, many hazardous, to keep themselves warm. It was the season of fire alarms.

The fire that morning was also the kind of event to which Weegee was regularly drawn. Alerted by his new police radio, he arrived in Brooklyn in time to witness Henrietta Torres and her daughter Ada, both tenants, learn that their relatives, Ramona Malave and her son, were trapped in the blaze. He opened his 4 × 5 Speed Graphic and took what became one of his most famous photographs (figure 22). Unlike many of his other pictures at fire scenes, this one did not accompany a news story about the event. At least two other photographers were on the spot: Irving Haberman, whose picture of the two women appeared in the *New York Post,* and an unknown photographer, whose picture of them appeared in the racier *New York Daily News.*[1] All three photographers had found the central drama of that morning's events in the women's shrieks.

Although Weegee's photograph was not immediately seen in the papers, it

Figure 22 Weegee (Arthur Fellig), *I Cried When I Took This Picture*, December 15, 1939.
© Weegee/International Center of Photography/Getty Images.

was reproduced in at least four other venues over the next several years before finally appearing in 1945 in *Naked City*. Only then, captioned in Weegee's book, did it obtain the title by which it has since become known, *I Cried When I Took This Picture*. Before that, it was printed without a title in a 1940 *PM Daily* article about the differences between picturing "real" and contrived emotions (see figure 23; it was judged "real"); again without a title in a 1941 camera magazine article by Weegee about the freelancer's secrets and strategies; for the first time with a title—aggressively nondescriptive—as *This Story Needs No Telling* in a 1944 *People's Voice* essay on fire prevention; and as the more descriptive but still generic *Fire* in 1945 in the upscale *Cosmopolitan* in an article about the modern-day photojournalist's intrepid nightlife.[2] In each case, its meanings mutated, becoming by turn an example of extreme emotional distress; a successful "story-telling" shot for the aspiring freelance photographer (because "story-telling fire pictures always sell; pictures of a burning building alone won't"); part of a plea in the fire prevention essay to cultivate, among other things, "good smoking habits";[3] and evidence of the nightly dramas the alert photographer, wielding his Speed Graphic, might capture. Over the years, the picture had been used for such different purposes that by 1945, when it appeared in *Cosmopolitan,* even Weegee had forgotten where he had photographed the original and who was pictured. Reproduced for "220 Minutes in the Life of a Naked City," an essay purportedly retelling his adventures over the course of a single night, the photo carried the following long caption: "The alarm was turned in at exactly 1:20. The box was at the corner of Lexington Avenue and 125th Street . . . a tenement . . . cause of fire unknown. It rated a tiny story in the papers. The one-column head ran: 'Child Burned to Death in Early Morning Blaze.' Definitely not a big story—that is, not big to anyone but that mother and daughter pictured below. The reason is simple. It was the woman's small son Johnny who didn't get out."[4]

In its *Cosmopolitan* guise, the photograph of Henrietta Torres and her daughter Ada had been transplanted over the East River from Brooklyn to Harlem, accompanied by a one-column newspaper article (when no such

article with that heading had ever appeared, and no original coverage had used Weegee's picture), and made part of a single evening's jaunt by the prowling photographer (it was juxtaposed with pictures taken, in fact, years apart); Ramona Malave and her son Edward had been transformed and merged into Johnny, the son of her aunt Henrietta (who had no sons). Because the photograph had lost any connections to its original context by the time it appeared in *Naked City,* Weegee could view the picture not as tied to a place and time or to a specific set of historical actors but instead as an occasion for maudlin self-reflection.

The curious life of this photograph allows me to introduce the central concerns of this essay: the publishing contexts in which Weegee's photographs, especially of immigrants and the tenement neighborhoods of New York, initially appeared and the eventual transformation of those photographs into *Naked City.* The shift in the photographs' meanings can be attributed to Weegee's growing (or manufactured) fame as a photographer, as he emerged as a star. In that environment, both he and his admirers happily reinterpreted his pictures not photojournalistically but creatively, not as reports of events but as expressions of himself. He cried when he took the photograph that cold December morning in Brooklyn, he tells us in *Naked City.* Yet, in this essay I wish to examine the cultural mechanisms by which this process of reinterpretation (of amnesia and solipsism) happened, tracing them back to an arena not normally associated with Weegee: the photographic cultures of the Left. I'll argue that his great book, *Naked City,* was not only strongly shaped by those cultures but, in fact, found a way to use and transform their political cast, an effort that won praise and, coming at the end of the Depression and the war, seemed to echo a more general disavowal of an engaged photographic practice. In all this, I do not claim that Weegee was ever a leftist photographer; he would sooner spout sayings from Groucho Marx than Karl Marx. But although he never proclaimed a left sensibility, his fascination with the city's poverty, distraction, and distress put him in its company. Indifferent as he remained to the Left, his photographs became part of its visual culture. The persona that *Naked City* cre-

ated and explored was, in a sense, pried from that culture. That effort can be glimpsed in the logic and layout of his book.

"I WAS IN A RUT," Weegee wrote of his early jobs in photography—an assistant to the professional studios, a passport photographer, and a darkroom techie. "I was unhappy and restless. . . . I knew I was destined for fame, for big things, and there I was still stuck in the darkroom developing other people's pictures. . . . I was itching to move ahead."[5] The hunger for "big things" was fed by the profusion of illustrated dailies, whose use of pictures increased yearly and whose distribution gave photojournalists unprecedented visibility, even some "fame." It was also facilitated by a global demand for news pictures and a novel means to feed that demand. In 1935, the year Weegee turned to freelance photography, the Associated Press established WirePhoto, the world's first wire service for transmitting news photographs. The founding of several large competitors, including Acme Newspictures and Wide World Photos, quickly followed. Weegee would supply pictures to all three agencies. As never before, there was now a ready means for hustlers and restless techies like Weegee to imagine a different role in photography—to take and publish pictures of news events as freelancers, have a ready means to distribute them widely, and get paid a living wage for them. Even as he gained fame as an expressive photographer, Weegee never forgot the commercial route he took to achieve it. "[G]o to a big syndicate like Acme or Associated Press," he told aspiring photographers in 1942, "and offer them the picture or set for their newspapers all over the world."[6]

But it was arguably at *PM Daily,* not the wire services or the other dailies, where Weegee found his most reliable publisher and avenue to fame. Beginning in 1940, Weegee's association with *PM* provided him a steady outlet for his photographs. It came with a retainer and credit line and, just as important, with a philosophy about the distinctive role of photography in producing a visual knowledge of the world. In *PM* Weegee found a paper that was as self-conscious as he was about visual meaning, its promotion, and its uses. The

paper established a new model of reportage based on a more capacious understanding of what photographs could do, not merely replicating the examples of other papers, which used pictures to augment their texts, but instead aiming to make photographs carry a burden of meaning. "*PM* is . . . a picture-newspaper," its editor William McCleery declared of this new thing. "We believe news photographs are not merely to be gaped at but also to be *learned from*."[7]

What did this learning consist of? To teach readers how to understand photographs, *PM* established a regular column explicitly devoted to the task. Organized and largely written by Ralph Steiner, *PM*'s picture editor, the column was simply called "Photographs" and gave practical advice, as outlined in an early issue: "*PM*'s Photography Department is conducted for the general reader who, seeing more and more photographs, wants to know something about the medium itself. By showing him various types of photographs, we hope to give him the means of judging for himself what makes a good photograph good. We shall not bore him with technicalities, but shall stick to those aspects of photography which have meaning and importance for every person with a pair of eyes."[8] Composed of a series of pictures and accompanied by Steiner's populist directives, "Photographs" explained to readers such things as how "muscles, not eyes, give facial expressions their meanings"; how to tell one nurse apart from another (figure 24);[9] and, as we have seen in the case of Weegee's picture of Henrietta Torres and her daughter, how to distinguish true from false emotions (see figure 22). Often, the advice for would-be photographers was prescriptive: for example, explaining the merits of visual repetition, the strategies for photographing a "foreign place," or the steps one needed to take to obtain not merely representative but "fine pictures" of children.[10] Weegee almost invariably contributed photographs as the teaching materials.

To demonstrate that photographs could have meanings apart from news copy, *PM* introduced a variety of page layouts and regular columns—appearing under such titles as "Ten Pages of News in Pictures," the "*PM* Gallery," and the "File and Forget" page—all composed entirely of images. As photo-essays, they

Figure 24 Weegee (Arthur Fellig) and others, "How to Tell One Nurse from Another," *PM*, July 14, 1940, 52. Photographs by Weegee © Weegee/International Center of Photography/ Getty Images.

asked readers to track stories by piecing together visual data. Sometimes the photographs were construed as a film strip, with images following an event in elapsed time. But most often they were linked by theme, by a repetition of subjects or gestures, or by the elaboration of a single, piercing visual detail. In "Chief Danger Point on Henry Hudson Parkway" (figure 25), we observe in the upper left panel the "danger point" on the parkway—a lamppost, curb, and concrete divider—highlighted by a white circle, as if it were a target for a speeding motorist. It is followed by a montage of pictures suggesting an impact—cars with their fenders crushed, headlights twisted, doors unhinged, hoods popped, front ends compressed like accordions. The photographs are joined as a call-and-response or an illustration of cause and effect—in this case, the call of the upright form of the lamppost and the response of the low forms of the smashed vehicles, the contrast between the single target and the visual repetition of damaged metal.

The fact that the photographs in "Chief Danger Point," nearly all from Weegee's files, were taken of starkly different locales and events was of little, if any, account. At one level, the call-and-response structure taught viewers (including Weegee) that news photographs had relevance beyond their recording of an event; their value also lay in being an archive of readable themes and gestures and a trove of endlessly recyclable materials for the new photo-essays and photo features—an understanding that Weegee took to heart. "You've been peddling the same pictures to us now for six years," he recalled an editor saying to him, "and, for all I know, it's the same dead gangster and the same gray fedora lying on the sidewalk."[11] The dead gangsters in gray fedoras became one of many usable visual notes, along with the smashed vehicle, the drunken reveler, the dozing man or woman, the ogling passerby, the smooching couple, the surprised burglar, the captured criminal, and on and on. They seemed to provide no end of details that might be mixed and matched. News photographs could take on a gestalt, as opposed to reportorial, logic: they could be related to each other by the force of recognizable rhymes and gestures, as opposed to events.

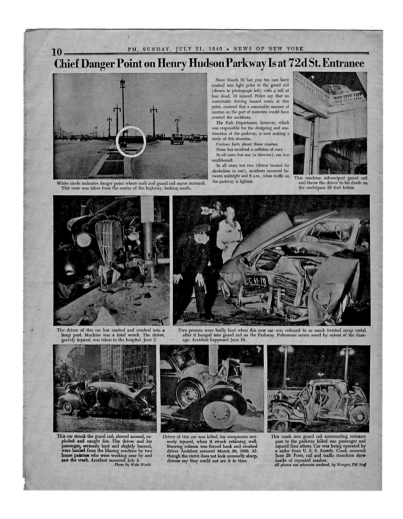

At one basic level, *PM*'s goal was both to accentuate and demystify photography, a task that included revealing the work behind the lens. When Weegee began to promote himself in the camera magazines and camera clubs, he almost always provided how-to instructions for his audience, as if these pointers, filled with technical specifications and practicalities, were simply part of elaborating this new thing, photojournalism. Even in *Naked City,* he organized his last chapter as neither a final summation about the city nor an assessment of his many pictures of it but instead a long essay he called "Camera Tips." "Don't try to guess focus," he told aspiring cameramen, "just practice six and ten feet." "When I am making close-ups at six feet, with the light from the flash bulb closer to the subject and hence stronger," he explained, "I step down to F.32." He informed those wondering what film he employed, "I use . . . a Super Pancro Press Type B." And he advised those amateurs tempted by the fancy new flashes being advertised against wasting their precious money, telling them, "I still use a flash bulb."[12]

At another level, the columns and picture spreads instilled beliefs about good news photographs, at least as Steiner and photojournalists like Weegee wanted to promote them. Consider another of *PM*'s directives, that a good news photograph must overcome a sitter's shyness or resistance. When a photographer faces a reserved subject, his "only hope is to fill his sitter's mind so full that there is no room for camera consciousness," Steiner explained. "Or the photographer must consciously use the shyness to make a picture."[13] When faced with shyness or, more frequently, resistance, Weegee thematized it (figure 26). Or consider Steiner's claim that "framing is justified only when the frame makes a comment on the subject framed and intensifies the statement."[14] Weegee offered an example in typically tongue-in-cheek style, one that deliberately "intensifies" a portrait of the fascist, anti-Semitic presidential candidate Joseph McWilliams (figure 27).

Weegee's work at *PM* reveals another side to the man. He was a showman, true, and an inveterate self-promoter who grandstanded (as circus clown, as cigar-chewing tough guy, as idiot savant) at every opportunity. But he was also

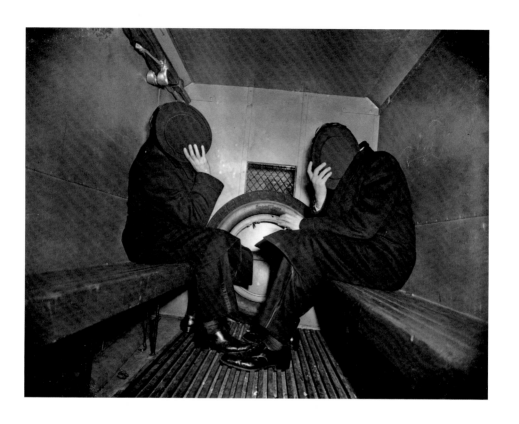

Figure 26 Weegee (Arthur Fellig), *In Top Hats—In Trouble,* January 27, 1942. © Weegee/
International Center of Photography/Getty Images.

Figure 27 Weegee (Arthur Fellig), "McWilliams, Fascist Candidate, Faces His Future Undiscouraged," *PM*, July 8, 1940, 10. Photographs by Weegee © Weegee/ International Center of Photography/Getty Images.

a practicing cameraman in a photojournalistic profession that was just taking flight, and he, along with those at *PM,* was caught up in its newness, thrill, responsibility, and sense of possibility.

PERHAPS THE MOST POPULAR of progressive photojournalism's teachings was about a subject called "human interest stories." This editorial program focused on the excesses and distractions of Depression-era Americans and opened up a huge field of inquiry that had rarely before been surveyed in the papers. It took as photogenic and newsworthy seemingly trivial subjects, everything from the carousers who nightly slummed in the Bowery to the thousands of New Yorkers who lived cheek by jowl in the overcrowded tenements and, in the wholesale effort on weekends to escape the crush of human bodies, simply transplanted their unruly mass wherever they went (figure 28). The appearance and experiences of the downtrodden and homeless, the attentions and behaviors of the glamorous, and especially the bad manners that erupted from a meeting between the two (figure 29)—these, too, were of human interest.

The appeal of such subjects lay not in their triviality—the excesses and distractions of New Yorkers were, for the newspapers, winningly trivial by definition—but in their choreography. "Silly and obviously fake human interest stories throw our guards up," Steiner declared, and were useless for the papers.[15] To obtain the right kind, Weegee offered practical advice, calling for every story pictured to be linked to a central actor, no matter how marginal he or she might have been as the drama unfolded. The prescription was literal. "Don't just take a shot of the smashed automobile," Weegee told a readership of would-be photojournalists. "Have somebody in it or near it—for human interest." If there were no witnesses available to enlist for the job, then go ahead and fabricate the human interest angle, he advised: "Get everything ready, then pose yourself, pointing to the smashed windshield" (figure 30).[16] Create a curious passerby, if need be (see figure 3). In the act of pointing at the details of an accident, that figure becomes, as in narrative or history painting, a compositional device that ties the scene to a human scale. But more than

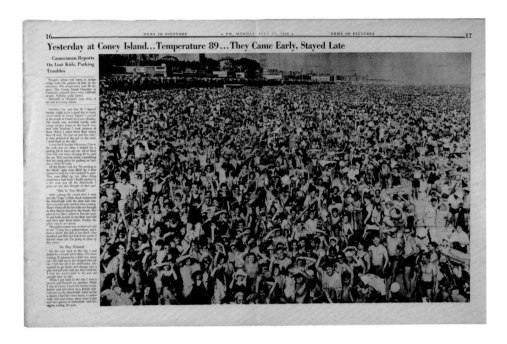

Figure 28 Weegee (Arthur Fellig), "Yesterday at Coney Island . . . Temperature 89 . . . They Came Early, Stayed Late," *PM,* July 22, 1940, 16–17. Photographs by Weegee © Weegee/International Center of Photography/Getty Images.

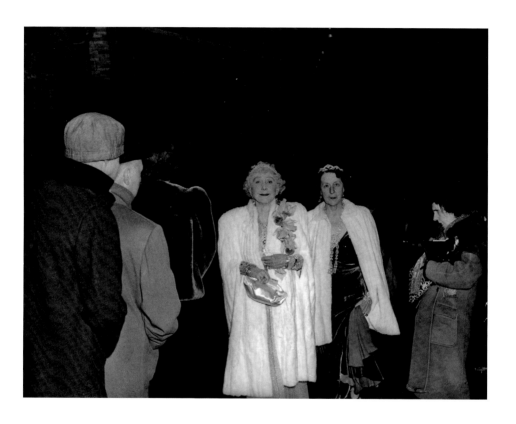

Figure 29 Weegee (Arthur Fellig), *The Critic*, 1943. © Weegee/International Center of Photography/Getty Images.

merely a prop or pointer, the figure also becomes a subject, however contrived or rudely inserted into the scene, a way to measure the import of events as a human drama. "Human interest is real tough to get in photographs sometimes," Weegee once claimed,[17] but his many photographs would seem to suggest quite the opposite. The idle figure, the crowd of witnesses, the fat cop, the boorish drunk, the unshaven janitor, the dozing moviegoer, and on and on— they appear everywhere in his work, pointing, laughing, pushing, winking, crying, intruding on the scene, draped over balconies, slumped on seats, wedged behind police cars and paddy wagons, climbing through broken glass, making themselves seen, and thereby giving the story human form. No picturing of a scene was complete without them.

"At first, I couldn't sell my pictures," Weegee confessed to his admirers in 1941. But as his picture of Henrietta Torres and her daughter suggests, he took his cue from editors, who told him "that a fire picture had to show more than the burning building. . . . So, at fires, the last thing I did from then on was to photograph the burning building. I always watch out now for the human element."[18]

While Weegee believed that human interest stories could be produced by simple choreography in front of the lens, for *PM* they were built out of unspoken assumptions about the importance of human scale for the paper's readers. Taken together, these stories produced and explored the tastes of readers assumed to be attentive to excess and distraction. Or to put it another way, human interest stories were offered to those assumed to be alienated from decision making and power.

PM differed from other picture tabloids not only in its more self-conscious use of photographs and photographic education, its celebrated refusal to accept commercial advertising, and its promotion of individual photographers, but also in its politically charged, left-leaning attitudes.[19] Its key editors and writers were all from the Left, including Herbert Rosen, who under the pseudonym David Ramsey was also the editor of the *Communist;* Leo Huberman, *PM*'s labor editor, who would soon found and edit the socialist *Monthly Review;*

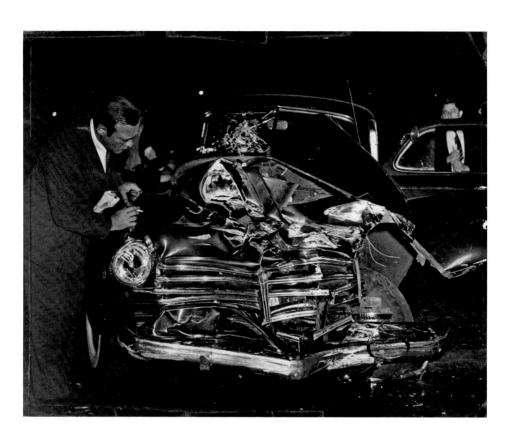

Figure 30 Weegee (Arthur Fellig), *Car crash*, 1941. © Weegee/International Center of
Photography/Getty Image.

James T. McManus, who was head of the left-wing Newspaper Guild; and James Wechsler, who had been a member of the Young Communist League. Throughout its life, *PM* was continually red-baited for employing politically radical writers and photographers; it sparred openly with other leftist publications, including the Communist Party's *Daily Worker* and *New Masses.*

PM's emphasis on the photography of human interest stories tried to answer a central question facing a left-leaning paper in the 1940s: how to incorporate popular culture into leftist activism. The Communist Party had always shown itself utterly incapable of and often averse to addressing American popular and mass culture, an inability that severely limited its appeal to the working classes.[20] Unlike the *Daily Worker* and *New Masses,* which although extraordinarily literary had always been more restricted in scope, *PM* reported on a wide range of topics—everything from news of labor organization and unrest to developments in the war to the fortunes of the Yankees and Dodgers to the results at the horse track. Alongside muckraking and inflammatory stories (*PM* was notorious for reproducing in its pages the pink dismissal slips its readers received from employers), it regularly covered sports, the listings of radio broadcasts, and the ever-changing New York nightlife; it pictured and named a weekly "*PM* swimsuit beauty"; and it ran a column on the weather, a weekly photo essay on "nature" (close-ups of plants and animals by Margaret Bourke-White), and frequent feature stories on Coney Island and professional wrestling. The paper tried to link the look and interests of other tabloids with the political, social, and economic issues that concerned the immigrant and working classes. The ambition caused no end of debate among leftists. Earl Browder, head of the American Communist Party, charged *PM*'s editors with a lack of discipline.[21] "How left are we?" *PM* asked its readers in response, and one of its many subscribers enthusiastically answered: "Is *PM* left? I'd say, 'right' or 'left,' let it be always *right* and the *color* won't matter."[22]

The photography of human interest stories was arguably *PM*'s most daring contribution to a populist leftism. It was rooted in the belief that *PM*'s readers not only were working class but also, like the men and women Weegee

regularly photographed in the tenements, were immigrants whose English was broken and who understood the American scene primarily through their immersion in mass culture. The tenements were filled with people who had only recently arrived in New York. By some estimates, three-quarters of those populations had immigrated within the past decade and a half, spoke a language other than English as their first tongue, or had members of their immediate family living in other lands. The ratios were in keeping with an overall trend of "new immigrants," mostly from southern and eastern Europe, as Weegee's family was; some five million Italians and four million Jews had entered the United States by 1930. The Italian neighborhoods in Manhattan and Brooklyn alone—among Weegee's favorite haunts—held nearly half a million people.[23]

PM's further innovation was to make a visual link for its readers between the travails at home and those abroad—that is, to argue photographically for the legitimacy of an immigrant experience. Consider again one of the early appearances of Weegee's *I Cried When I Took This Picture* (see figure 23). Part of *PM*'s education program, the picture spread instructed readers how "to distinguish between the real emotion in a picture and badly-acted emotions." It's hard to measure readers' response to the proposal—the "true" on the left, the "false" or "badly-acted" on the right ("Did you ever actually pull your hair to express your desperation?" Steiner asked earnestly).[24] But whatever the success of the panels in elevating its readers' skills, more important are the kinds of examples it offered to get their attention. On the side of the "true," they show a Czechoslovakian woman forced to salute the entry of Nazis into her city, an immigrant woman who cries out to her husband as he is being deported for illegal entry into the United States, men and women protesting a cut in their relief pay and forcibly removed from city hall, and Henrietta Torres and her daughter Ada (identified as "this girl and her mother") bewailing the fire in their tenement and the unknown fate of their relatives. In contrast to Hollywood's "false" images, the immigrant's experience—in *PM*'s view, typified in hunger, unemployment, the loss of home because of military occupation or dis-

aster, worries about deportation—could never be thought of as anything but "true," evidence of "being hit by life and reacting to the blow."[25] A link between the traumas at home and abroad is suggested in the form of the wife straining after her lost husband, who is being forcibly returned to their war-torn homeland and its tragedies.

WE CAN SEE THE WAYS in which *PM* was attractive to an ambitious photographer like Weegee, but why was Weegee, hardly a leftist photographer, attractive to *PM?* A partial answer can be found in Steiner's belief, elaborated repeatedly in *PM,* in local knowledge. "I've said it before, and I'm saying it again because it's the most important thing there is to say to photographers," he declared. "[T]he gospel that should be handed down from Mount Kodak: *Photograph things around you—things that you know about and like—love— hate.*"[26] By background and temperament, Weegee fit the bill. A habitué of the tenement neighborhoods, a night crawler of the Bowery whorehouses and bars, a regular on the streets in Chinatown and Little Italy, Weegee was every bit a man of immigrant and working-class New York. Even his earliest work as a hustling street photographer was dependent on his social skills in the immigrant ghettos, taking pictures of the children on weekends and, during the week, going door-to-door with his prints to charm doting parents into a purchase. "The people loved their children," he observed, "and, no matter how poor they might be, they managed to dig up the money for my pictures." He also understood their anxieties about ethnicity, race, and discrimination. "I would finish the photographs on the contrastiest paper I could get in order to give the kids nice white, chalky faces. My customers, who were Italian, Polish or Jewish, liked their pictures dead-white."[27] In short, Weegee was a portraitist of the immigrant working classes.

But he was not the only one with local knowledge, and *PM* was also drawn to Weegee—as it was to Gene Badger, Hugh Broderick, John De Biase, Morris Gordon, Irving Haberman, Mary Morris, even the nationally famous Margaret Bourke-White—because in the competitive New York newspaper

market it wanted to monopolize talent. The stable of skilled photographers led to a lively, competitive atmosphere, observable in the dialogue and tit-for-tat play between pictures in the newspaper. Take the following interchange as one small but representative example. In the July 25, 1940, issue of *PM,* Margaret Bourke-White published a photograph of the New York weatherman and celebrity James Kimball, a "man who ignores the heat" (figure 31). That July was staggeringly hot, but Kimball, as portrayed by Bourke-White, "never sheds his coat, never opens his hard collar, never loses patience when asked to explain what humidity is or the difference between a cyclone and a tornado."[28] An image of starched composure, the portrait matched Bourke-White's own vaunted identity at *PM* as a figure who commanded the largest pay, biggest credit lines, and most regular features. Three days later, in the July 28 issue, *PM*'s other photographers replied. In a picture spread of workers and occupations, they depicted the other side of the July heat: men at hard physical work—a baker here, a truck driver there, a road crew at work on the steaming asphalt (figure 32). They were unstarched and in various states of undress; the Bronx baker at lower left, pictured in front of the stifling oven fire, had disrobed and made a "diaper" for himself out of flour sacks. But the closest to naked of all, at lower right, was the ungainly Weegee himself. In answer to Bourke-White's image of cerebral composure, Weegee offered his own overflowing flesh. It was a winning reply, since he knew that Bourke-White couldn't and wouldn't doff her clothes and flaunt herself in the same way, and it appealed to working-class machismo. Weegee was showering to cool off in the stifling summer heat, but this did not mean he was different from other working stiffs, somehow avoiding work. "Note camera release in his hand," *PM* was careful to point out.[29]

The sparring between photographers led Steiner to make two further observations about photography in *PM,* both of which soon held particular relevance for Weegee. Despite their seeming transparency as documents, the photographs in the newspaper demonstrate an important point, Steiner told readers, having to do with individual personalities and sensibilities: "the relation

Figure 32 Weegee (Arthur Fellig) and others, "They'd Sooner Be at the Beach But, Heat or No Heat, Jobs Are Scarce," *PM*, July 28, 1940, 16–17. Photographs by Weegee © Weegee/ International Center of Photography/Getty Images.

between the man who snaps the shutter and the picture which comes out of the developer is much closer than most photographers think."[30] A week later, he elaborated:

Years ago newspaper photographers were hard-boiled and little more than that. Today there are two types: the hard-boiled and the sensitive. . . . The hard-boiled photographer is better on highly dramatic assignments such as riots, murders, or wars, which demand courage, coolness and physical strength. He must force his way into places hard to get to or where he isn't wanted. He must be tough and go without sleep or sufficient food for days at a time. . . . The sensitive photographer comes into his own when the subject is physically easy to get, but must be made interesting through direction, unusual point of view, or deep feeling. He is often sent out when the drama of a situation is under the surface; when the crisis is yet to come, or when it has passed.[31]

Soon after, when Weegee began to declare himself a creative photographer and turned away from the car accidents and gangland murders that had formed a central element of his early work, he looked to the formulation offered by Steiner as a way to describe who he was becoming. "I'm very sens'tiff and artistic and hate the sight of blood," he observed of himself.[32] By then he had been a newspaper photographer for nearly a decade and was fully steeped in its culture. There were no other sets of terms for an identity as a photographer that made as much sense to him. If not hard-boiled, he would be full of deep feeling. If not the tough-talking, wisecracking, idiot savant cameraman, he would become the sensitive and expressive man in search of drama.[33]

A CIRCA 1939 PICTURE shows Weegee in his apartment amid the already glamorous trappings of his trade (figure 33): an alarm clock to rouse him for the nightly treks; a police radio to alert him to sudden events; a flashbulb box full of photographs and papers, evidence of a growing archive of edgy work. Tacked on the back wall are pictures of Weegee himself: playfully behind bars, as if he were a mobster finally caught; holding his Speed Graphic and ready to shoot; smoking his ever-present stogie; juxtaposed with *Mad* magazine's Al-

fred E. Newman, a campy, idiot alter ego. Called *My Studio,* the picture suggests that the photojournalist's work is as conducive to creating a personality as it is to addressing the city's happenings.

Weegee's first attempt to go public with this personality, in the sense that he and his photographs could appear entirely outside their usual place in the printed press, took place in the 1941 one-man exhibition called Murder is My Business at New York's Photo League (see figure 1). While the exhibit did not entirely disavow the newspaper origins of the photographs, the placards on which Weegee's photographs were mounted tended toward presenting the montage of images—without captions, full of self-references and silly puns—that he had assembled in *My Studio.* Only a few display placards contained original newspaper clippings; one featured a picture spread of a society gathering at the Waldorf-Astoria Hotel combined with an article, written by Weegee himself, from the April 18, 1941, issue of *PM* (see figures 11 and 12). But even this clipping, which by its mere presence announced the newspaper origins of the photographs on display, seems to have been chosen in part to complicate those origins. "Why, I don't know," Weegee had written in the article's first sentence, "but I was assigned to cover the Cinderella Ball."[34] The tough street photographer had better uses for his time than to take fashion pictures, he seems to declare, as if the Waldorf spread was an anomaly in the context of the real work of his camera, the work of picturing murder and more murder. Or better still, the article was chosen because it announced not the events at the Waldorf but instead the unlikely transformation of the hard-boiled photographer in search of danger into the sensitive photographer in search of Cinderella Ball drama.

An accumulation of themed pictures from Weegee's archive, Murder is My Business represented the city as a shadowy night filled with undifferentiated violence and catastrophe, creating the palpable but unspecified ambience of grittiness and darkness developed more famously four years later in *Naked City.* The displays transformed news photographs into a photographer's dramatic view. But the ambition to go public ought to be understood in relation to the

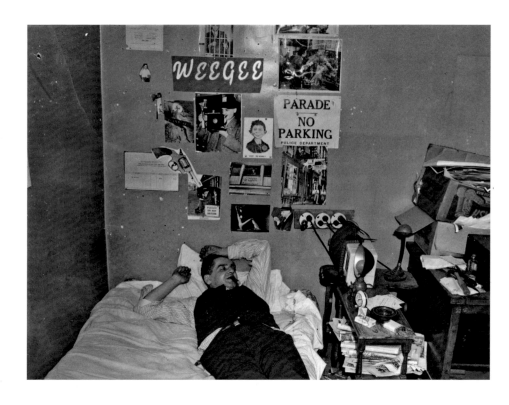

Figure 33 Weegee (Arthur Fellig), *My Studio*, ca. 1939. © Weegee/International Center of Photography/Getty Image.

exhibition's venue, the Photo League. It was precisely the Photo League's com-
plicated commitments—its left-leaning sensibility, its experiments in social
documentary, its enthusiastic but also loosely defined ideas about a working-
class imagery—that enabled Weegee's photographs in Murder is My Business
to sit at the unusual crossroads of newspaper reportage, photo feature, and au-
tobiography and eventually to announce his turn to a form of expressiveness.
Furthermore, the Photo League provided Weegee a usable template for the
nonjournalistic display of his work.

Formed in 1936, just a year after Weegee had turned to freelance work, the
Photo League was an offshoot of the politically radical Film and Photo League.
It occupied a small walk-up on Twenty-first Street on the fringes of the labor
union district and was led by a coterie of activist photographers; most of them,
like Weegee, were the children of Jewish immigrants, born and raised in the
tenements, modestly educated, and largely self-taught with the camera. Some,
like Weegee, came from the extreme poverty of the Lower East Side. "Sid
[Grossman]," recalled the photographer Louis Stettner, "like Weegee, came
from the poorest working class. . . . I remember him telling me of the bitter
poverty experienced by his family, who went with hardly anything to eat for
months at a time."[35] The tough experiences (and common anti-Semitism) in
the tenement neighborhoods and on the mean streets made Grossman, Stett-
ner, Sol Libsohn, Walter Rosenblum, and most of the other prominent figures
in the Photo League leftists, fellow travelers, and activists. Its members made
the Photo League an experimental organization—part school, part laboratory,
part studio, part social club—as they sought a means to link social, political,
and camera work. Among their most lasting legacies in this vein was the de-
velopment of urban documentary projects: collaborative ventures by Photo
League members who together explored, photographed, and reported on New
York's subcultures. Prior to Weegee's exhibition, they had already completed
several of their most important documents, including *Portrait of a Tenement*
(1937), *Sixteenth Street: A Cross-Section of New York* (1940), *Lost Generation: The*

Plight of Youth Today (1940), and, perhaps the most ambitious and well-known of all, *Harlem Document* (1938–40).

How a figure like Weegee wound up exhibiting at the Photo League has always been something of a mystery. One reasonable answer is that the Photo League, in inviting Weegee, was pursuing its charge to serve as a laboratory of innovations in the medium for its students and members. From its founding, the Photo League had always tried to accommodate a range of photographers and photographic ideas, displaying not only an educational but also a Popular Front mentality in the realm of camera work. Before showing Weegee's work, it had either invited to lecture or offered exhibitions to photographers as astonishingly dissimilar as Ansel Adams, Berenice Abbott, Margaret Bourke-White, Lisette Model, László Moholy-Nagy, Aaron Siskind, and Paul Strand. Compared with much of their camera work, Weegee's—blunt in its point-blank stare, shot at night with a blazing flash, candid about disaster and urban disorder, attentive to the emotional fallout of violence—showed a closer if sometimes only approximate relationship to Photo League concerns. Some in the League had reservations about his happy disregard about where his pictures got published—he still sent his pictures to the trashy tabloids, such as the *Mirror* and *Daily News,* a few members complained—but his work for the outspoken *PM* had given him a rough-hewn allure, a sense that he was in the forefront, certainly on the front pages, of protest journalism. Another reasonable answer is that the Photo League and *PM*, both emphasizing photography and a left-leaning sensibility, cultivated close bonds. Less than a year before Weegee's exhibit, Ralph Steiner gave a much-celebrated lecture at the Photo League titled "Art and Documentary Photography"; three months later, photographs from a documentary project by Walter Rosenblum and Dave Joseph called *Pitt Street* were placed in *PM*.[36]

But a third answer might be that there was a moment—fleeting, as it turned out—when the Photo League's documentary projects and Weegee's photo features could be thought of as being in a dialogue. On the surface, the projects and features had things in common. The Photo League's photographers ap-

proached their urban subjects like feature reporters. They conducted interviews, developed shooting scripts, canvassed neighborhoods with their cameras, met afterward like an editorial board to discuss the shots, and as a group planned picture spreads and accompanying texts on the Photo League's exhibition walls and, in some cases, in book maquettes. They had in mind the same newsworthy neighborhoods that preoccupied *PM*'s photojournalists, and, like staff photographers, they imagined that their pictures of these neighborhoods and residents were not solitary or individual expressions but parts of an ensemble of information, which included long captions, charts, essays, and detailed statistics. Their shooting scripts were aimed at uncovering variations on themes, much as feature stories did, as in "Chief Danger Point on Henry Hudson Parkway" (see figure 25). In a segment on religion in the *Harlem Document,* for instance, the shooting script called for pictures of the "Multiplicity of Church buildings and denominations: a. Pentecostal Church, b. Divine, c. 'recognized' Protestant, d. Catholics, e. Spiritualists, f. voodoo."[37] The organizational logic—theme and variation—was not so far removed from that of a Weegee picture spread, with its accumulation of twisted fenders, popped hoods, and unhinged doors.

The complicated displays of these projects were as celebrated as the photographs themselves. I know of no early pictures documenting the Photo League's installations, but a contemporaneous review by the art critic Elizabeth McCausland—this one of the 1940 *Chelsea Document*—gives us a rough idea of how they looked:

The "Chelsea Document," which has been exhibited at the Photo League, the Chelsea Tenants' League, the Hudson Guild and elsewhere, is an excellent demonstration of a field in which the Photo League may well be the pioneer. . . . The brief text has been used admirably to knit together the photographic material. "We Live Here," the first panel proclaims, with a panorama of old law multiple dwellings in the shadow of London Terrace. The conditions are sub-human[:] of every 10 dwellings, 9 are over 40 years old; yet the average obsolescence of buildings in New York is closer to 20 years than 30,–that is, where the rentiers

make profit by tearing down and building here. . . . "WHY" asks a third panel, "Why do we live this way? We don't have to—if we organize to fight for . . ." The answer is government housing, on the basis of specific needs—another health center, 50 acres of playgrounds, a 500-bed hospital, parks for mothers, low-rent apartments. . . . [In] five 4-by-8 foot panels, photographs, figures, words, symbols, arrows, guidelines, in black and in color, join to accuse the City of New York of its failure to its citizens.[38]

The statistics come tumbling forth: the specifications of this dwelling, that proposal, this number of years, that number of acres, these needs of the community, those miscarriages of civic duty. McCausland did not need to have these details at her fingertips, for they were already included on the panels as lists and floating captions, accompanying the montage of photographs and linked to them with arrows, pointers, and signs.

McCausland had reservations about the panels, too, and these provide further clues about how they looked:

The exhibition suffers from handicaps which are understandable. The actual rendering of the panels could be more workmanlike. For example, if the wallboard had been painted a dead white before any visual material had been applied, the impact of the photographs, the lettering and the colored symbols would be more immediate and powerful. It is also always a little disturbing to see the photographs curling away from their supports. . . . The problem of presenting photographs graphically is a complex one. Generally in this case the written and painted material comes off better than the photographic. Whether this is due to the failure of the photographer to make the most of his subject matter or whether it means the designer over emphasized his share of the collaboration is a question. . . . This may mean that in such graphic presentation larger photographs should be used. Speaking of craftsmanship, it is a little distracting to the eye to note the fact that the panorama of the first panel does not match up.[39]

So the photographs were small, the design a little obtrusive, the written materials sometimes more compelling than the images, the pictures peeling away from their mountings and a little off-kilter. The exhibitions had a makeshift

or in-progress quality, and the balance between word and image was not fully worked out.

What is abundantly clear is that Weegee organized his display along the same lines as previous Photo League shows: each rectangular panel in a series carried photographs, papers, signs, and large headings. He maintained the in-progress quality, with photographs mounted crudely and askew, but made sure to paint his panels white and enlarge his images. Limiting his words to large stenciled cutouts, he sought a different balance between words and images. In all these procedures, the handcrafted quality of the exhibition was initially less a sign of Weegee's authorship than of his adhering to, and trying to improve on, the Photo League's documentary displays. Or perhaps it is more accurate to say that his growing sense of authorship—the way he learned to signal his personality in an exhibition—was facilitated by the installation strategies he had previously seen in the Photo League.

Weegee's reinterpretations of those strategies are easy to spot in the ways he made hay with the Photo League's ethos. Instead of arrows, we confront goofy cartoon pistols with their long barrels pointing to the panel's details; the pistols were reproductions of the one pictured in his *My Studio* portrait, only now they were dripping cartoon blood (see figure 9). Instead of statistics on the needed hospital beds or open parks, we find an invoice Weegee received for his photographic services and a copy of his press credentials. Instead of captions that point to the need for intervention in the slums, we read clippings about high society. Instead of revealing texts (McCausland wrote approvingly of the *Chelsea Document*'s accompanying texts that "crime against the moral sense of mankind . . . can only be realized through the medium of language"),[40] we find a large placard containing the prankish claim "This Space Reserved for the Latest Murders" (see figure 11), which, in framing an empty space, reveals nothing at all. Some of the letters have been applied backward, less like the Photo League's handicraft than like a child's scrawl. Weegee even had himself pictured applying the ingredients, making sure that no one mistook the source of their gaucherie (figure 34). Accompanied by cutouts of Weegee, the

panels in Murder is My Business both borrow and mark their distance from the Photo League's document.

Such manipulations helped underscore the differences between the document and the news photograph, between the activist sensibility of the Photo League and the concerns of the photojournalist, and between the collaborative ventures of left-leaning photographers and the increasingly sens'tiff Weegee. Those differences were acknowledged in the responses to the show, which alternated between, on the one hand, attempts to bring the panels in line with activist thinking and, on the other, utter fascination with their prurient and mawkish details. On the mawkish side, there were those who responded to the unrelieved blood. "Have gone away for the week end to recuperate," observed one viewer in the guestbook.[41] There were those who interpreted the show as connected not in any way to Photo League debates but instead to Weegee himself, recognizing his attempt to go public as an auteur: "Weegee—top man on a sordid camera"; "How can I too become a Weegee?"; "Are there any schools teaching how to become Weegies [*sic*]?" On the side of political progressiveness, there were those, like Louis Stettner, who tried to imagine the show as an inquiry into the city as capitalist machine. "[K]nowing New York City," he wrote of Weegee, the photographer had offered an unrelieved scrutiny into "the heart of the whole industrial system."[42] But it was hard to sustain that kind of argument in the face of so much popular attention that paid no heed to it. Exhibited on their own, spread-eagled across large white placards, full of interest in sensational murder and shock, the photographs could smack too much of a voyeur's heated gaze. Murder is My Business had the effect of bringing out Weegee's connections to the documentary, only to have them show how they could facilitate his self-promotion.

Grossman would soon break with Weegee, never to invite him to show at the Photo League again. "He saw Weegee betraying his own past, and the class to which he belonged," Stettner observed.[43] But by then, from Weegee's perspective, it did not matter what anyone at the Photo League thought. Despite or perhaps indeed because of his exhibition there, he could build an artistic

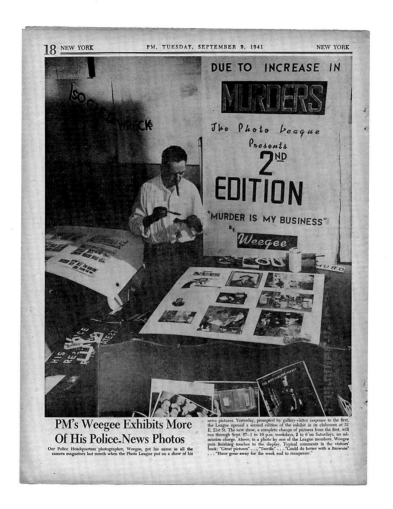

Figure 34 Weegee (Arthur Fellig), "PM's Weegee Exhibits More of His Police-News Photos,"
PM, September 9, 1941, 18. Photographs by Weegee © Weegee/International Center
of Photography/Getty Images.

temperament, using the Photo League's exhibition as a model and also a testing ground to stage and then strip away anything remotely social from his work and to insist on his own glamour. Of the compulsive emphasis on violence and bloodshed in his pictures, seemingly so at odds with the tendrils of a deep-feeling soul, he soon explained that he was "spellbound by the mystery of murder."[44] The explanation was far more elegant and succinct than Weegee normally mustered. But by then he was savvy enough to know he needed to cultivate that more poetic, less hard-boiled voice.

ACCORDING TO HIS OWN ACCOUNT, Weegee was inspired to collect his pictures into a single volume because of the enthusiastic response to the 1944 show of his photographs at New York's Museum of Modern Art.[45] But in fact, the idea of collecting and publishing his pictures was raised three years earlier by Louis Stettner at Murder is My Business. "I suggest that he should write a book illustrated with his photographs," Stettner had written in Weegee's comment book for that show.[46] Stettner had meant for such a book to make good on the inquiry into "the heart of the whole industrial system"; but by the time of the MoMA exhibition, the push toward a sensitive photography, only provisionally on display at Murder is My Business, had set into motion an entirely different idea for a book. *Naked City,* therefore, ought to be seen as the culmination of a change in direction begun at least three years earlier and confirmed by the shift in venues for Weegee's photographs from the Photo League to MoMA, from the socially conscious to consciously fine art, and from the newspapers to the gallery wall. The pictures had not changed—images of life in the tenement neighborhoods still filled his boxes—but the meanings that could be attached to them had altered dramatically.

One way to understand *Naked City,* then, is to see it as a prolonged attempt by Weegee to explore the idea of authorship that he and others began ascribing to his photographs. The presentation of his picture of Henrietta Torres and her daughter, especially the new caption announcing how he had cried when he snapped their picture, was only the baldest instance of this effort. It offered

a simple reversal of focus, which shifted to, literally, the opposite side of the camera lens, from the wailing women to the weeping photographer. The collection is everywhere suffused by expressions that bend the pictures of others back to Weegee. "What I felt I photographed," he declares in the introduction, as if it were his own inner drives—and not the broadcasts on the police radio—that pushed him to the nighttime scenes.[47] Often he depicts his responses to the obsessions and travails of others. "This always makes me cry" (52), he notes of fire scenes when the bodies of victims are recovered. "Not so long ago I, too, used to walk on the Bowery, broke" (158), he muses of his photographs of the homeless. "Laugh—it's good for you," he writes of his pictures of the circus crowds. "I even laughed myself . . . and forgot all about my inferiority complexes" (94).

As if to acknowledge that *Naked City* was founded on his photojournalistic past, Weegee opens the first chapter with a photograph of newspapers bundled and tossed on the sidewalks, awaiting their morning delivery (see figure 6). The morning papers once represented the end of a hard night's work for him, the final destination for photographs taken, printed, and sold to editors and the wire services during the wee hours. But in *Naked City,* the papers represent not the endpoint but the beginning for another, more personal excursion. The photograph also serves as a commentary on Weegee's new relationship to them. That year, New York's newspaper delivery workers had gone out on a long and bitter strike, nearly bringing the city's journalism to a halt. *PM* championed the strike (it was one of the few papers whose delivery workers had been unionized), and when it was over and the strikers' demands were met, it provided generous coverage of their triumph. "Happy that their strike is over," *PM* observed, and the paper provided images of the grinning deliverers gathered for work once more (figure 35).[48] In this context, Weegee's image seems to disavow both the strike and the workers' labor. His streets are empty: the papers have magically appeared without any apparent agency. The bundles cast long shadows and suggest not the arrival of news but, as he writes in the caption, a kind of early morning loneliness. "New Yorkers like their Sunday

papers," he observes, "especially the lonely men and women who live in furnished rooms" (14), like him.

In keeping with the display strategies learned from the Photo League, Weegee organized his book with many of the same headings he used in Murder is My Business: "Murders," "Fires," "Coney Island," and more. He made sure to include the invoice he had first presented in that show. He developed a chapter on Harlem, which served as an acknowledgment, and perhaps an outdoing, of the Photo League's famed *Harlem Document.* In answer to the Photo League's strategy of mounting graphic signs with its pictures, Weegee devoted a chapter entirely to signs, though in his case the signs advertise pinup girls, a toupee, and horseflesh.

To help increase the solipsism and heighten the emotionality of his book, he mixed images from different stories, juxtaposing pictures made years apart but, in *Naked City,* related by the force of his own sens'tiffness. In a chapter on murders, he presented what has become one of his most famous photographs, later titled *Their First Murder* (see figure 14).[49] "A woman relative cried," he writes of the scene, "but neighborhood dead-end kids enjoyed the show when a small-time racketeer was shot and killed." "Here he is," Weegee tells us of the image on the opposite page, "as he was left in the gutter" (86–87). Gazing toward the dead man's body, a woman wails, a boy laughs with glee, a girl is wide-eyed in her efforts to comprehend, the boys in the back crane to see, the crowd is unruly and unpredictable. As in a call-and-response, the prone body is contrasted with the crowd's upright mass, his stilled arms and legs with their fury and tangle, his bloodied face with their gleaming, straining, and crazed eyes. The effect of the contrast is vivid and chilling. The problem, however, is that the photograph of the dead man belonged to another street, event, and murder, in no way related to the original scene from which *Their First Murder* was taken. And the children were not "dead-end kids" but, as *PM* reported in its original 1941 coverage, students ending their day at a Brooklyn public school. Across from P.S. 143, they had witnessed a gruesome murder and been jostled about as the gunman escaped past them.[50] These pictures, culled from different

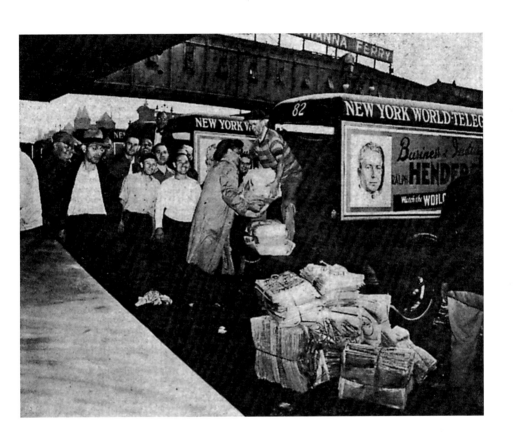

Figure 35 John De Biase, "Happy that their strike is over," in *PM*, July 18, 1945, 11.

sources in his haphazard collection, and the captions, insisting on the unrestrained glares of passersby, served Weegee's purpose. "People get bumped off," he philosophized, yet their broken and bloody bodies, seemingly countless, never failed to draw interest, even from children. The crowds, it turns out, are like him, spellbound by the mystery of murder. But in this case, they had experienced what he could only imagine. "Some day I'll follow one of these guys," he promised, "have my camera all set and get the actual killing" (78). In the pages of *Naked City,* the children stand in for him, witnesses to an event he did not see and could concoct only in his book. We learn that the intensity of their responses to their first murder is an approximation of his longing to witness *any* murder.

To call attention to his own lewd urges, Weegee revamped the "newsreel" structure he had learned from the illustrated dailies. Take the fate of Joe Doakes. Initially offered in a 1943 issue of *PM* as an example of the common man's wariness at the news of Mussolini's ousting (figure 36; he appears at the upper left), he reappears, nameless, in *Naked City* in a spread of portraits taken on the streets (figure 37). Divided across the two pages—across the gutter that separates one page from the next—men and women are separated into equal halves. Originally interpreted as being wary (or pensive, bored, or distracted), Doakes, along with the other men and women, is instead given a more explicit sexual charge, as he and they ogle each other—man eyeing woman, woman demurely returning or deflecting his gaze, a young black man looking at an older white woman, Doakes pondering his options in the array of available women before him. Other pictures were reversed and cropped to put their subjects in a proper position to see and be seen. The oglers suck thumbs and pick teeth, pull on lips and noses, press and contort their mouths, as if in their desires they are indulging in or regressing into an infantile pleasure. The effect is goofy and even a bit tasteless, on a par with the broad, adolescent humor and schoolboy naughtiness first glimpsed in Murder is My Business. With men and women facing off in a primitive drama of the sexes, even the page gutter is given a risqué meaning, a visual pun on its vernacular usage. The gutter is now

potentially dirty, uncouth, degraded, sinful, and naughty. To pass from one page to the next, in the exchange of desiring gazes, is to risk crossing a sinful divide. Just as *PM*'s original "Newsreel" had declared of its spreads, the layout of Joe Doakes and his companions offered "good pictures of things really happening."

IN *NAKED CITY* WEEGEE WAS ALLOWED to imagine an entirely different audience for his work, far removed from the kinds of readers who had once given life to *PM*. "Weegee today is Art," *Newsweek* exclaimed in 1945, just after the book was released. "Whether or not he is a good artist," the *New York Times* chimed in, "he possesses a good artist's unsentimental outlook."[51] Even Alfred Stieglitz, the aged impresario of modernist photography, sent Weegee a private note of congratulations. "My laurel wreath I hand to thee," he wrote grandly.[52] The national magazines—*Time, Cue,* even *Mademoiselle*—sent Weegee telegrams asking for lengthy interviews.[53] Where once he had a mostly local following, *Naked City* made him a national celebrity almost overnight.

What had happened to make this possible? My argument has been that in *Naked City* Weegee drew not only his raw materials but also most of his strategies from the original publishing and exhibiting contexts for his photographs: first at *PM,* which in its self-conscious use of photographs and photographers gave Weegee a set of visual ideas and a descriptive language about the pictures and himself, and then at the Photo League, which provided him with a documentary template for organizing and displaying his work. They both happened to be left-leaning models, whose purposes were rooted in activist ideals. And in truth, how could the apolitical Weegee avoid somehow coming into contact with them? All three—Weegee, *PM,* and the Photo League—took New York's immigrant and working-class streets as their subject matter. To repeat my original claim: the persona that *Naked City* created and explored was pried from that culture, and in a close reading of his pictures, the marks of that effort can still be glimpsed.

Figure 36 Weegee (Arthur Fellig), "The news about Mussolini comes to Broadway and 42d St.," *PM,* August 1, 1943, 7. Photographs by Weegee © Weegee/International Center of Photography/Getty Images.

Figure 37 Weegee (Arthur Fellig), from *Naked City*, 38-39. © Weegee/International Center of Photography/Getty Image.

A larger context greeted the effort and ensured its triumph. That is, the photographs could function as portrayals of the photographer and the riveting but contextless aura of New York, and not of the difficulties experienced by those who lived in the tenements, only when immigrants such as Henrietta Torres and her daughter Ada no longer seemed to command the attention of the nation. The pictures could go from being steeped in social meaning to being the work of an auteur when the need for human interest stories for and about *PM*'s people began to fade away.

At least three very large historical developments help explain the shift. The first had to do with a national bout of amnesia: in 1945, Americans preferred to forget all the savagery, madness, violation, and guilt that had characterized the previous decade and a half. It is telling that a book like *Naked City,* although coming on the heels of World War II and the Great Depression, hardly refers to them and for the most part actively disavows them. "Too much war news!" Weegee had once complained in 1944. "My free lance photographic business has taken a nose dive."[54] Yet the wish to escape war and economic disaster went far beyond one man's desires. A whole society preferred to forget.

The second was the death of Franklin Delano Roosevelt in April 1945 and the loss of his liberal pragmatism and moral force. It gave momentum to the red-baiting Republican and corporate backlash that had already begun undoing labor's gains during the New Deal. The stand against left and liberal politics was almost immediately felt in Weegee's world. As the cold war began, *PM*'s pro-labor sympathies and more accommodating attitude to the Soviet Union made it a target of the conservative Hearst, Scripps-Howard, and McCormick-Patterson newspapers. They eventually combined to keep *PM* from receiving an all-important Associated Press contract, reducing the paper's ability to cover events broadly and forcing its editors to cut back its pages and reluctantly accept corporate advertising. In a climate of outright hostility to left-leaning journalism, the denouement was not far off. In 1948, two years after the Republicans had taken control of both houses of Congress for the first time since before Roosevelt had taken office, and three years after the House

Un-American Activities Committee (HUAC) had been made a permanent standing committee with the express purpose of ferreting out anything that smacked of radical politics in the United States, *PM* quietly folded.

While the first two developments brought about a repression or elimination of interest in the daily plight of the immigrant working classes, the third was far more salutary: a slew of legislative changes that encouraged a greater sense of belonging among those who previously had been denied it. These included the lifting in 1952 of immigration quotas in place since the 1920s, which soon led to a trickle and then a steady stream of new immigrants into the country, and the passing of new laws to admit refugees from a devastated European continent. Yes, the new openness was driven by cold war politics, as the hallowed image of America as a safe haven for the world's oppressed was resurrected in the face of Communism. But the net effect for the immigrant poor already living in the tenement neighborhoods, especially Jews and Italians, was a path toward a fuller, participatory citizenship after years of suffering hostility and neglect. Discrimination continued, of course, as did the same political and economic hardships described by *PM,* but the new laws offered a new kind of hope. Protest journalism lost some of its force, and certainly most of its readership. At one time alienated from the mainstream press, *PM*'s readers no longer had to look to a left-leaning publication to find their concerns—their image of themselves—in print.

IT IS ONE OF THE great ironies of *Naked City* that although it established Weegee as an expressive photographer and helped prepare the way for his work to enter—and belong in—art museums, it produced one of the purest forms of the tabloid as we know it today. What we think of nowadays as the most characteristic features of the newsstand tabloid—an overblown sense of passion and emotion; a cultivation of grand melodrama; a blurring of the distinctions between documentary, fiction, news, and entertainment; a fascination with the scandalous and grotesque and with social and moral disorder; a stress on storytelling over fact-finding; a hankering after images that are raw, vulgar, or

pornographic; a loathing for anything that smacks of objectivity, detachment, and critical distance—are all massively in evidence in *Naked City*. And, in truth, how could they not be? At a historical moment when the immigrant working classes were beginning to disappear from the pages of protest journalism, they could be safely transformed into fiction in *Naked City*. In the book's pages, without the sustaining force of progressive news, reportage, or social documentary, human interest stories could become caricature—a hyperbolic, grandly melodramatic, and solipsistic representation of life on the working-class streets.

Notes

We wish to thank Erin Barnett and Chris George at the International Center of Photography for helping us sift through Weegee's large archives and view and obtain his photographs; Stephanie Fay and Eric Schmidt, editors extraordinaire at the University of California Press, for shepherding this book through all its stages; and Alice Falk for copyediting with care and sensitivity. In October 2006, Richard Meyer presented his research on Weegee to the Department of History of Art Colloquium at the University of Pennsylvania. He would like to thank David Brownlee, Michael Leja, Christine Poggi, and Gwendolyn Dubois Shaw for their excellent suggestions and intellectual generosity and David Román for his love and support. Anthony Lee would like to thank Sarah Greenough and Therese O'Malley for inviting him to present an earlier version of his essay at the Center for Advanced Studies in the Visual Arts at the National Gallery of Art, and Andrew Hemingway, Naomi Rosenblum, and other members of the audience who offered generous and helpful comments.

Introduction

1. Arthur Fellig, *Naked City* (New York: Essential Books, 1945), 91. This work is hereafter cited parenthetically in the text.

2. "The Press: Modest and Assuming," *Newsweek,* July 23, 1945, 74.

3. Warren I. Sussman, *Culture as History: The Transformation of American Society in the Twentieth Century* (New York: Pantheon, 1984), 111.

4. On the spectacular success of *Life,* see Erika Doss, introduction to *Looking at Life Magazine,* ed. Doss (Washington, D.C.: Smithsonian Institution Press, 2001), 1–21.

5. The most up-to-date bibliography of Weegee's writings and interviews, and also

of writings about Weegee, can be found in Luc Sante et al., *Unknown Weegee* (New York: International Center of Photography, 2006), 143–49. The radio interview was broadcast on the Mary Margaret McBride show; for a transcript, see "Weegee," June 11, 2000, at www.soundportraits.org/on-air/weegee/transcript.php3 (accessed July 23, 2007).

6. Arthur Fellig, *Weegee by Weegee: An Autobiography* (New York: Ziff-Davis, 1961), 14.

7. Fellig, *Weegee by Weegee,* 42.

8. Fellig, *Weegee by Weegee,* 37.

9. Fellig, *Weegee by Weegee,* 34.

10. "Weegee: Murder is My Business," *Photo Notes,* September 1941, 2.

Learning from Low Culture / Richard Meyer

1. "Gang Stabs B'kyln Man 48 Times," *New York Post,* August 5, 1936, 1, 10.

2. "Gang Stabs B'kyln Man 48 Times," 10.

3. "Speaking of Pictures . . . A New York Free Lance Photographs the News," *Life,* April 12, 1937, 8.

4. "Speaking of Pictures . . . This is a Jewish Wedding," *Life,* April 5, 1937, 4–5, 7; "Speaking of Pictures . . . These are the Exercises of Yoga," *Life,* April 19, 1937, 8–9.

5. "Speaking of Pictures . . . This is a Brain Operation," *Life,* November 30, 1936, 3.

6. "Speaking of Pictures . . . A New York Free Lance Photographs the News," 8. The spread in *Life* became a blueprint for the feature stories on Weegee that quickly followed in both photographic trade magazines and the popular press. These include Rosa Reilly, "Free-Lance Cameraman," *Popular Photography* 1, no. 8 (December 1937): 21–23, 76–79; Arthur "Weegee" Fellig, "So You Want to Be a Free-Lance!" *Good Photography,* no. 7 (1941): 6–11, 132–33, 141; Ralph Steiner, "Weegee Lives for His Work and Thinks Before Shooting," *PM,* March 9, 1941, 49; Norman C. Lipton, "'Weegee' Top Free-Lance Tells How He Does It," *Photography Handbook,* no. 10 (1942): 6–11, 134–35; and Weegee, "Punch in Pictures," *U.S. Camera,* March 1943, 15–18.

7. "Speaking of Pictures . . . A New York Free Lance Photographs the News," 8.

8. It also includes at least one clipping with a photograph by Fellig: namely, the front-page tenement fire posted on the upper right section of the wall, above the alarm clock. This clipping is from Reilly's 1937 *Popular Photography* article "Free-Lance Cameraman" (23). The page in question includes Weegee's photograph of a tenement fire above

the caption "A fire in the slums of Suffolk Street, New York City, at its height." My thanks to Christopher George, archivist at the ICP, for pointing out this reference.

9. "Fellig," the article elsewhere declares, "has no home, no wife, no family, doesn't seem to want any" ("Speaking of Pictures . . . A New York Free Lance Photographs the News," 8).

10. "Speaking of Pictures . . . A New York Free Lance Photographs the News," 8.

11. Arthur Fellig, "Naked Weegee," interview by Gretchen Berg, *Photograph* 1, no. 1 (Summer 1976): 3. The interview was conducted in 1965.

12. Reilly, "Free-Lance Cameraman," 21.

13. One important though as yet unpublished exception to this rule is a paper by Jason Hill, a Ph.D. candidate at the University of Southern California, titled "The Killer Apparatus: Four Fragments on Weegee, Photography, and the Proximity of Death." Hill offers a brilliant account of two Weegee murder photographs originally published in *PM* (*Bandit,* August 11, 1941, and *Sidney Salles,* April 18, 1941). In response to John Coplans's claim for the "artistic horror" of such photographs, Hill writes, "The discovery of 'artistic horror' in Weegee's photograph depends entirely on the removal of his images from the context of the newspapers they were produced to enliven." Hill generously shared his paper, written for a graduate seminar with Thomas Crow, with me.

14. The most incisive accounts to date of Weegee's relation to the tabloid press are provided by Miles Barth, "Weegee's World," in *Weegee's World* (New York: International Center of Photography, 1997), 11–35, and V. Penelope Pelizzon and Nancy M. West, "'Good Stories' from the Mean Streets: Weegee and Hard-Boiled Autobiography," *Yale Journal of Criticism* 17, no. 1 (Spring 2004): 20–50. See also Pelizzon and West, "Multiple Indemnity: Film Noir, James M. Cain, and Adaptations of a Tabloid Case," *Narrative* 13, no. 3 (October 2005): 211–37. Although I am indebted to each of these sources for their insights and information about Weegee and tabloid journalism, none reproduces any original spreads from the 1930s or '40s.

15. On these technological advances, see William Hannigan, "News Noir," in *New York Noir: Crime Photos from the Daily News Archive,* by Hannigan and Luc Sante (New York: Rizzoli, 1999), 15–22, as well as John Szarkowski, introduction to *From the Picture Press,* ed. Szarkowski (New York: Museum of Modern Art, 1973), 5–6.

16. According to the communications scholar Karen Becker, "It was in the tabloid press of the 1920s that large sensational photographs first appeared, with violence, sex,

accidents, and society scandals as the major themes" (Becker, "Photojournalism and the Tabloid Press," in *Journalism and Popular Culture,* ed. Peter Dahlgren and Colin Sparks [London: Sage, 1992], 133).

17. According to the press historians Kevin G. Barnhurst and John Nerone, "By the early 1920s, halftone photography was widely adopted by the illustrated press although the pictures usually could capture only a single shot of static scenes or people in stiff poses (as the larger cameras and explosive flashes required). For publication, pictures were corralled into their own neighborhoods by mounds of froth lines" (Barnhurst and Nerone, *The Form of News: A History* [New York: Guilford Press, 2001], 141).

18. Advertisement for "The News: New York's Picture Newspaper," in *Time,* March 8, 1937, 39. According to the ad, as of February 1937 the paper had a daily circulation of 1,650,000, rising to 3,100,000 on Sundays.

19. Editorial, *Illustrated Daily News,* June 26, 1919; reprinted in William Grosvenor Bleyer, *Main Currents in the History of American Journalism* (Boston: Houghton Mifflin, 1927), 423.

20. "Who Reads the Tabloids?" *New Republic,* May 25, 1927, 6.

21. "The Tabloid," *Nation,* June 15, 1927, 661.

22. Alfred McClung Lee, *The Daily Newspaper in America: The Evolution of a Social Instrument* (1937; reprint, New York: Macmillan, 1947), 275–76.

23. Arthur Fellig, *Naked City* (New York: Essential Books, 1945), 14; unless otherwise noted, ellipses in text quoted from Fellig are his.

24. Colin Westerbeck, *Bystander: A History of Street Photography: with a New Afterword on Street Photography since the 1970's,* text by Westerbeck, folios by Joel Meyerowitz (New York: Bulfinch, 2001), 337. See also Westerbeck in "An Elusive Fame: The Photographs of Weegee," a roundtable in *Weegee: Photographs from the J. Paul Getty Museum,* by Judith Keller (Los Angeles: Getty Publications, 2005), 101.

25. See Fellig, "So You Want to Be a Free-Lance!" 11; Fellig, *Naked City,* 78.

26. Arthur Fellig, *Weegee by Weegee: An Autobiography* (New York: Ziff-Davis, 1961), 65.

27. As Ellen Handy has suggested of the photograph of the payment for the murders, "a witty and ironic translation of Weegee's graphic crime photography into this concise and reductive format is virtually Duchampian. The image's insistence upon the commercial function of his work and its negotiability in the free market of images

is an important aspect of Weegee's work. Few previous photographers have called attention so deliberately to their own roles as authors and producers of imagery, to the economic basis of their production, and to the circulation of images in the larger economy" (Handy, "Picturing New York, the Naked City: Weegee and Urban Photography," in *Weegee's World,* by Miles Barth [New York: International Center of Photography, 1997], 149–50).

28. Fellig, *Weegee by Weegee,* 40.

29. Weegee, "Punch in Pictures," 15.

30. Weegee, "Punch in Pictures," 14.

31. Arthur "Weegee" Fellig and Mel Harris, *Weegee's Secrets of Shooting with Photoflash as Told to Mel Harris* (New York: Designers 3, 1953), 22.

32. Weegee, "Weegee, as Clown, Covers Circus from Inside . . . These Are Pictures He Took of the Crowd," *PM,* July 9, 1943, 12. Despite the claim made here, his infrared photographs of couples on the beach at night would soon be deemed "satisfactory" enough to be reprinted in *Naked City* (see Fellig, *Naked City,* 180–85).

33. Weegee, "Weegee, as Clown, Covers Circus from Inside," 12.

34. Weegee, quoted in Florence Meetze, "How 'Pop' Photo Crashes an Opening," *Popular Photography* 1, no. 8 (December 1937): 37. He explains in his memoir, "I had a roving assignment from *PM* for the next four-and-a-half years. I picked my own stories. When I found a good one, I brought it in. All they had to do was mail me a weekly check for seventy-five dollars . . . which they did" (Fellig, *Weegee by Weegee,* 86).

35. Weegee, "Weegee Photographs Society at the Waldorf," *PM,* April 18, 1941, 16.

36. Weegee, "Weegee Photographs Society at the Waldorf," 16.

37. "Weegee Covers Society," *PM,* December 3, 1940, 2.

38. Steiner, "Weegee Lives for His Work and Thinks Before Shooting," 49.

39. "Weegee," *New York Times,* July 22, 1945, 102; Aaron Sussman, "The Little Man Who's Always There," *Saturday Review of Literature,* July 28, 1945, 17; "Weegee," *Time,* July 23, 1945, 70; "The Press: Modest and Assuming," *Newsweek,* July 23, 1945, 74; "Naked City," by Weegee, *Washington Post,* July 29, 1945, S5.

40. Miles Orvell, "Weegee's Voyeurism and the Mastery of Urban Desire," *American Art* 6, no. 1 (Winter 1992): 23.

41. "This week, 228 Weegee photographs and 9,000 Weegee words appear in a book, Naked City (Essential Books, $4), that O. Henry might have done if he had worked with a Speed Graphic" ("Weegee," *Time,* July 23, 1945, 70).

42. William McCleery, foreword to Fellig, *Naked City,* 6.

43. Paul Strand, "Weegee Gives Journalism a Shot of Creative Photography," *PM,* July 22, 1945, 13.

44. Fellig, *Naked City,* 78, 83. This work is hereafter cited parenthetically in the text.

45. Arthur Fellig, introduction to *Weegee's People* (New York: Essential Books, 1946), n.p.

46. As Max Kozloff notes, Weegee "imagined in the '50s that his Picassoid distortions and cartoon trick lens shots of celebrities, everywhere dismissed, were his real, 'high,' art. In this, of course, Weegee misunderstood the fact that his own gift for caricature depended on the opportunity furnished by news" (Kozloff, "Mass Hysteria: The Photography of Weegee," *Artforum* 36, no. 7 [March 1998]: 79). For examples of the dismissal of Weegee's later work, see Jacob Deschin, "Weegee's Career," *New York Times,* October 29, 1961, X21 (Deschin calls the late work "merely comical and grotesque, with hardly more than the ephemeral value of a raucous, often indecent joke"); Anat Rosenberg, "Weegee: Distortions," *Art on Paper* 5, no. 2 (November–December 2000): 89–90; Anastasia Aukeman, "Weegee's Trick Photography," *Art on Paper* 7, no. 6 (April 2003): 60; Ken Johnson, "Art in Review: Weegee's Trick Photography," *New York Times,* February 7, 2003, E39; and J. Hoberman, "American Abstract Sensationalism," *Artforum* 19, no. 6 (February 1981): 42–49. On the occasion of a recent exhibition titled Weegee: Distortions, the Matthew Marks Gallery noted that "Weegee received virtually no encouragement for this work from the 'serious' photography or art world which, to this day, has continued to embrace only his earlier 'straight' photography" (press release, Matthew Marks Gallery, "Weegee: Distortions," June 3–July 28, 2000).

47. Louis Stettner, introduction to *Weegee,* ed. Stettner (New York: Alfred A. Knopf, 1977), 19.

48. The same photograph is used on the cover of the Da Capo paperback edition of *Naked City* currently in print.

49. Stettner, introduction to *Weegee,* 19.

50. Ben Lifson, "Acquainted with the Night," *Village Voice,* October 24, 1977, 101.

51. Gene Thornton, "The Satirical, Sentimental Weegee," *New York Times,* September 18, 1977, 19.

52. I am echoing here a roundtable on Weegee that took place in 2005. The relevant exchange is as follows:

I.R. [Ira Richer]: As Colin [Westerbeck] read that [passage from *Naked City*], it reminded me not of a photographer, but of a detective.

J.K: [Judith Keller]: Sure. Sam Spade. Mike Hammer.

M.O. [Miles Orvell]: Weegee has a similar kind of polarity between the tough guy and the sentimentalist.

("An Elusive Fame: The Photographs of Weegee," in Keller, *Weegee,* 101).

53. "Gang Kills Aspirant to Luciano's Power," *New York Post,* August 7, 1936, 1.

54. The erroneous identification is sometimes made, however; see, for example, Kerry William Purcell, *Weegee* (London: Phaidon, 2004), text facing plate 1 (unpaginated).

55. Weegee used the term "still life" to describe his photograph of a police officer's uniform, gun, and billy club on a pier—items that the police officer had hastily shucked off before jumping into the water to save someone from drowning (see Weegee and Harris, *Weegee's Secrets of Shooting with Photoflash,* 27).

56. It was during this period, according to Louis Stettner, that there "emerged, for the first time, Weegee's lecherous voyeurism (for example, a woman's bare behind protruding from draperies), which plagued him for the rest of his life" (Stettner, introduction to *Weegee,* 15).

57. Ginger Ungemacht, "I Covered a Gang War," *Photo,* August 1953, 123–30.

58. "Speaking of Pictures . . . Weegee Shows How to Photograph a Corpse," *Life,* August 12, 1946, 8–10.

59. Weegee, quoted in Steiner, "Weegee Lives for His Work and Thinks Before Shooting," 49.

60. Weegee's first exhibition in a commercial gallery, so far as I have discovered, was in the 1949 Los Angeles exhibition at the Fraymart Gallery (see "Development of Art Subject Told in Show," *Los Angeles Times,* July 24, 1949, D6). But not until the late 1970s were Weegee's photographs regularly shown in museums and galleries.

61. Weston Naef, *Photographers of Genius at the Getty* (Los Angeles: J. Paul Getty Museum, 2004); Robert A. Sobieszek, *Masterpieces of Photography: From the George Eastman House Collections* (New York: Abbeville Press, 1985).

62. Phillips New York, "A Sale of Photographs by Weegee," January 31, 2000, 74.

63. Weegee, quoted in "Weegee: Murder is My Business," *Photo Notes,* September 1941, 2.

64. Thomas Crow, "Modernism and Mass Culture in the Visual Arts," in *Modern Art in the Common Culture* (New Haven: Yale University Press, 1998), 33.

65. On this issue, the scholarship of Lawrence Levine—particularly *Highbrow/ Lowbrow: The Emergence of Cultural Hierarchy in America* (Cambridge, Mass.: Harvard University Press, 1990)—furnishes an important model. In a related essay, Levine notes: "The aesthetic quality of an artifact does not necessarily determine its level of complexity or the amount of analysis essential to comprehend its meaning. One does not have to believe that, aesthetically, Superman rivals Hamlet or that Grant Wood compares to Michelangelo to maintain that Superman and Wood potentially have much to tell us about the Great Depression, that they therefore merit the closest examination, and that they will not necessarily be simple to fathom" (Levine, "The Folklore of Industrial Society: Popular Culture and Its Audiences," *American Historical Review* 97, no. 5 [December 1992]: 1376).

66. Clement Greenberg, "Avant-Garde and Kitsch" (1939), in *Art and Culture: Critical Essays* (Boston: Beacon Press, [1961]), 9.

67. Clement Greenberg, "The Camera's Glass Eye: Review of an Exhibition of Edward Weston" (1946), in *The Collected Essays and Criticism,* ed. John O'Brien, 4 vols. (Chicago: University of Chicago Press, 1986–93), 2:61.

68. Greenberg, "Avant-Garde and Kitsch," 5.

69. Clement Greenberg, "Four Photographers: Review of *A Vision of Paris* by Eugène-Auguste Atget; *A Life in Photography* by Edward Steichen; *The World Through My Eyes* by Andreas Feininger; and *Photographs by Cartier-Bresson,* introduced by Lincoln Kirstein" (1964), in *The Collected Essays and Criticism,* 4:183.

70. Greenberg, "Four Photographers," 4:187.

71. Fellig and Harris, *Weegee's Secrets of Shooting Photoflash,* 21.

72. Andy Grundberg, "Photography," *New York Times Book Review,* December 7, 1997, 36.

73. Fellig, *Weegee by Weegee,* 37; ellipsis added after "babies."

Human Interest Stories / Anthony W. Lee

1. Haberman's photograph appeared in "Mother and Son Die in B'klyn Fire," *New York Post,* December 15, 1939, 40; the other photograph appeared in "Fire Brings Sorrow," *New York Daily News,* December 15, 1939, 40.

2. Ralph Steiner, "These Are Real People Showing Emotion . . . and These are Models 'Acting' Emotion," *PM,* July 25, 1940, 48; Arthur "Weegee" Fellig, "So You Want to Be a Free-Lance!" *Good Photography,* no. 7 (1941): 7; "Prevent This," *People's Voice,*

October 7, 1944, 10; and "220 Minutes in the Life of a Naked City," *Cosmopolitan* 119, no. 1 (July 1945): 50.

3. Fellig, "So You Want to Be a Free-Lance!" 6; "Prevent This," 10.

4. "220 Minutes in the Life of a Naked City," 50; ellipses in the original.

5. Arthur Fellig, *Weegee by Weegee: An Autobiography* (New York: Ziff-Davis, 1961), 25, 35.

6. Weegee, quoted in Norman C. Lipton, "Weegee Top Free-Lance Tells How He Does It," *Photography Handbook,* no. 10 (1942): 134.

7. William McCleery, "Camera Reveals How Campaigning Has Altered Wilkie's Personality," *PM,* October 20, 1940, 47; emphasis in the original.

8. Ralph Steiner, "Faces You Like Make Likeable Pictures," *PM,* July 14, 1940, 49.

9. Ralph Steiner, "Look Again! These Photos Prove Muscles, Not Eyes, Give Facial Expressions Their Meanings," *PM,* August 24, 1941, 48–49; Helen Gwynn, "How to Tell One Nurse from Another," *PM,* July 14, 1940, 52.

10. Ralph Steiner, "Repetition: Bad and Good," *PM,* September 22, 1940, 48–49; Steiner, "To Photograph a Foreign Place . . . You Need to Get Under Its Skin," *PM,* July 21, 1940, 48; Steiner, "This Is the Way to Take Fine Pictures of Children," *PM,* December 22, 1940, 48–49.

11. Fellig, *Weegee by Weegee,* 45–46.

12. Arthur Fellig, *Naked City* (New York: Essential Books, 1945), 239.

13. Ralph Steiner, "The Way People React to a Camera Is Revealing," *PM,* September 15, 1940, 48.

14. Ralph Steiner, "'Framing' Doesn't Necessarily Make a Picture Good," *PM,* December 15, 1940, 48.

15. Ralph Steiner, "Some Photographers Make England Look Like This," *PM,* November 24, 1940, 49.

16. Weegee, quoted in Rosa Reilly, "Free-Lance Cameraman," *Popular Photography* 1, no. 8 (December 1937): 23.

17. Weegee, quoted in Reilly, "Free-Lance Cameraman," 76.

18. Fellig, "So You Want to Be a Free-Lance!" 10.

19. The debates on the left-liberal tenor of *PM* persist. For a view of *PM* as primarily liberal, see Paul Milkman, *PM: A New Deal in Journalism, 1940–1948* (New Brunswick, N.J.: Rutgers University Press, 1997).

20. In the teens, the *Masses* recognized this same problem and also attempted to in-

corporate aspects of popular culture in its pages. I know of no direct connection between the editorial staffs at *PM* and the *Masses,* but the older paper provided one important model for all progressive papers. On the *Masses'* popular visual culture, see Rebecca Zurier, *Art for the Masses: A Radical Magazine and Its Graphics, 1911–1917* (Philadelphia: Temple University Press, 1988).

21. A. B. Magil, "'PM' and the Communists," *New Masses,* April 11, 1944, 15–17.

22. Louise Hofer, "Our Readers Talk Back," *PM,* August 24, 1941, 34.

23. The numbers vary, depending on the sources. But see John Mack Faragher et al., *Out of Many: A History of the American People,* 3rd ed. (Upper Saddle River, N.J.: Prentice Hall, 2000), 708–10.

24. Steiner, "These Are Real People Showing Emotion," 49.

25. Steiner, "These Are Real People Showing Emotion," 49.

26. Steiner, "This Is the Way to Take Fine Pictures of Children," 48; emphasis in the original.

27. Fellig, *Weegee by Weegee,* 18.

28. "Portrait of a Man Who Ignores the Heat," *PM,* July 25, 1940, 10.

29. "They'd Sooner Be at the Beach But, Heat or No Heat, Jobs Are Scarce," *PM,* July 28, 1940, 17.

30. Ralph Steiner, "Can You Tell Which of These Men Took Which of These Photographs?" *PM,* September 29, 1940, 48; entirely italicized in the original.

31. Ralph Steiner, "It Takes Both Thick and Thin-Skinned Photographers to Cover News," *PM,* October 6, 1940, 48.

32. Weegee, quoted in Earl Wilson, "Weegee," *Saturday Evening Post,* May 22, 1943, 37.

33. On Weegee's relation to "hard-boiled autobiography," see V. Penelope Pelizzon and Nancy M. West, "'Good Stories' from the Mean Streets: Weegee and Hard-Boiled Autobiography," *Yale Journal of Criticism* 17, no. 1 (2004): 20–50. See also Patricia Vettel-Becker, *Shooting from the Hip: Photography, Masculinity, and Postwar America* (Minneapolis: University of Minnesota Press, 2005), 61–78.

34. Weegee, "Weegee Photographs Society at the Waldorf," *PM,* April 18, 1941, 16.

35. Louis Stettner, "Cézanne's Apples and the Photo League," *Aperture,* no. 112 (Fall 1988): 32. On Grossman, see Anne Tucker, "Sid Grossman: Major Projects," *Creative Camera,* nos. 223–24 (July–August 1983): 1040; Les Barry, "The Legend of Sid Gross-

man," *Popular Photography,* November 1961, 51, 94; and Lili Corbus Bezner, *Photography and Politics in America: From the New Deal into the Cold War* (Baltimore: Johns Hopkins University Press, 1999), 73–120. On Stettner, see his own *Louis Stettner: Wisdom Cries Out in the Streets* (Paris: Flammarion, 1999).

36. On Steiner's lecture, see "Ralph Steiner at the League!" *Photo Notes,* September 1940, 1–2. On the placement of the *Pitt Street* project in *PM,* see "Walter & Dave in the *PM,*" *Photo Notes,* January 1941, 2.

37. As recorded in Anne Tucker, "A History of the Photo League: Its Members Speak," *History of Photography* 18, no. 2 (Summer 1994): 178.

38. Elizabeth McCausland, "The Chelsea Document" (May 1940), transcribed at http://newdeal.feri.org/pn/pn540b.htm (accessed July 24, 2007).

39. McCausland, "The Chelsea Document."

40. McCausland, "The Chelsea Document."

41. Reported in "PM's Weegee Exhibits More of His Police News Photos," *PM,* September 9, 1941, 18. Apparently written in the visitor's book, this comment was a response to the slightly revised "second edition" of the show.

42. Comments recorded in visitor's book, Weegee Archives, International Center of Photography, New York.

43. Stettner, "Cézanne's Apples," 33.

44. Weegee, quoted in Wilson, "Weegee," 37.

45. Fellig, *Weegee by Weegee,* 81.

46. Louis Stettner, comment recorded in visitor's book, Weegee Archives.

47. Fellig, *Naked City,* 11. This work is hereafter cited parenthetically in the text.

48. Karl Pretshold, "Newspaper Delivery Strike Ends," *PM,* July 18, 1945, 11.

49. The famous title was not given to the photograph until it appeared in Weegee's 1961 autobiography, *Weegee by Weegee.*

50. "Brooklyn School Children See Gambler Murdered in Street," *PM,* October 9, 1941, 10.

51. "The Press: Modest and Assuming," *Newsweek,* July 23, 1945, 74; Russell Maloney, "Portraits of a City," *New York Times,* July 22, 1945, 96.

52. Alfred Stieglitz, letter to Arthur Fellig, September 11, 1945, Weegee Archives.

53. See, for example, Eleanor Tatum, *Time Magazine,* telegram to Arthur Fellig, July 11, 1945, Weegee Archives. Not all the requests for interviews were so uninter-

ested in Weegee's tabloid past. An example: "We're doing an article on ghost spooks and spirits for October issue would like very much to have your statement on do you believe in them and if so when and where have you ever seen any" (Susan Kuehn, *Mademoiselle,* telegram to "Weegee Care Julius's Bar," July 24, 1946, Weegee Archives).

54. Weegee, quoted in "Dear Joe," *PM,* March 5, 1944, 10.

Works Cited

Aukeman, Anastasia. "Weegee's Trick Photography." *Art on Paper* 7, no. 6 (April 2003): 60.

Barnhurst, Kevin G., and John Nerone. *The Form of News: A History.* New York: Guilford Press, 2001.

Barry, Les. "The Legend of Sid Grossman." *Popular Photography,* November 1961, 51, 94.

Barth, Miles. "Weegee's World." In *Weegee's World,* 11–35. New York: International Center of Photography, 1997.

Becker, Karen. "Photojournalism and the Tabloid Press." In *Journalism and Popular Culture,* edited by Peter Dahlgren and Colin Sparks, 130–53. London: Sage, 1992.

Bezner, Lili Corbus. *Photography and Politics in America: From the New Deal into the Cold War.* Baltimore: Johns Hopkins University Press, 1999.

Bleyer, William Grosvenor. *Main Currents in the History of American Journalism.* Boston: Houghton Mifflin Company, 1927.

"Brooklyn School Children See Gambler Murdered in Street." *PM,* October 9, 1941, 10.

Crow, Thomas. *Modern Art in the Common Culture.* New Haven: Yale University Press, 1998.

"Dear Joe." *PM,* March 5, 1944, 10.

Deschin, Jacob. "Weegee's Career," *New York Times,* October 29, 1961, X21.

"Development of Art Subject Told in Show." *Los Angeles Times,* July 24, 1949, D6.

Doss, Erika. Introduction to *Looking at Life Magazine,* edited by Doss, 1–21. Washington, D.C.: Smithsonian Institution Press, 2001.

Faragher, John Mack, et al. *Out of Many: A History of the American People.* 3rd ed. Upper Saddle River, N.J.: Prentice Hall, 2000.

Fellig, Arthur. *Naked City.* New York: Essential Books, 1945. (Also published abridged as a pulp paperpack [Cincinnati: Zebra Picture Books, 1945].)

———. "Naked Weegee." Interview by Gretchen Berg. *Photograph* 1, no. 1 (Summer 1976): 1–4, 24, 26.

———. "Punch in Pictures." *U.S. Camera,* March 1943, 15–18.

———. "So You Want to Be a Free-Lance!" *Good Photography,* no. 7 (1941): 6–11, 132–33, 141.

———. *Weegee by Weegee: An Autobiography.* New York: Ziff-Davis, 1961.

———. *Weegee's People.* New York: Essential Books, 1946.

[Fellig, Arthur] Weegee, and Mel Harris. *Naked Hollywood.* New York: Pellegrini and Cudahy, 1953.

———. *Weegee's Secrets of Shooting with Photoflash as Told to Mel Harris.* New York: Designers 3, 1953.

"Fire Brings Sorrow." *New York Daily News,* December 15, 1939, 40.

"Gang Kills Aspirant to Luciano's Power." *New York Post,* August 7, 1936, 1, 24.

"Gang Stabs B'kyln Man 48 Times." *New York Post,* August 5, 1936, 1, 10.

Greenberg, Clement. "Avant-Garde and Kitsch." In *Art and Culture: Critical Essays,* 3–21. Boston: Beacon Press, [1961].

———. *The Collected Essays and Criticism.* Edited by John O'Brien. 4 vols. Chicago: University of Chicago Press, 1986–93.

Grundberg, Andy. "Photography." *New York Times Book Review,* December 7, 1997, 36.

Gwynn, Helen. "How to Tell One Nurse from Another." *PM,* July 14, 1940, 52.

Handy, Ellen. "Picturing New York, the Naked City: Weegee and Urban Photography." In *Weegee's World,* by Miles Barth, 148–58. New York: International Center of Photography, 1997.

Hannigan, William. "News Noir." In *New York Noir: Crime Photos from the Daily News Archive,* by Hannigan and Luc Sante, 15–22. New York: Rizzoli, 1999.

Hoberman, J. "American Abstract Sensationalism." *Artforum* 19, no. 6 (February 1981): 42–49.

Hofer, Louise. "Our Readers Talk Back." *PM,* August 24, 1941, 34.

Johnson, Ken. "Art in Review: Weegee's Trick Photography." *New York Times,* February 7, 2003, E39.

Keller, Judith. *Weegee: Photographs from the J. Paul Getty Museum.* Los Angeles: Getty Publications, 2005.

Kozloff, Max. "Mass Hysteria: The Photography of Weegee." *Artforum* 36, no. 7 (March 1998): 76–81.

Lee, Alfred McClung. *The Daily Newspaper in America: The Evolution of a Social Instrument.* 1937. Reprint, New York: Macmillan, 1947.

Levine, Lawrence. "The Folklore of Industrial Society: Popular Culture and Its Audiences." *American Historical Review* 97, no. 5 (December 1992): 1369–99.

———. *Highbrow/Lowbrow: The Emergence of Cultural Hierarchy in America.* Cambridge, Mass.: Harvard University Press, 1990.

Lifson, Ben. "Acquainted with the Night." *Village Voice,* October 24, 1977, 101.

Lipton, Norman. "'Weegee' Top Free-Lance Tells How He Does It." *Photography Handbook,* no. 10 (1942): 6–11, 134–35.

Magil, A. B. "'PM' and the Communists." *New Masses,* April 11, 1944, 15–17.

Maloney, Russell. "Portraits of a City." *New York Times,* July 22, 1945, 96.

McCausland, Elizabeth. "The Chelsea Document," May 1940. Transcribed at http://newdeal.feri.org/pn/pn540b.htm (accessed July 24, 2007).

McCleery, William. "Camera Reveals How Campaigning Has Altered Wilkie's Personality." *PM,* October 20, 1940, 47.

———. Foreword to Fellig, *Naked City,* 6–7.

Meetze, Florence. "How 'Pop' Photo Crashes an Opening." *Popular Photography* 1, no. 8 (December 1937): 36–38, 80–81.

Milkman, Paul. *PM: A New Deal in Journalism, 1940–1948.* New Brunswick, N.J.: Rutgers University Press, 1997.

"Mother and Son Die in B'klyn Fire." *New York Post,* December 15, 1939, 40.

Naef, Weston. *Photographers of Genius at the Getty.* Los Angeles: J. Paul Getty Museum, 2004.

"Naked City," by Weegee. *Washington Post,* July 29, 1945, S5.

Orvell, Miles. "Weegee's Voyeurism and the Mastery of Urban Desire." *American Art* 6, no. 1 (Winter 1992): 19–41.

Pelizzon, V. Penelope, and Nancy M. West. "'Good Stories' from the Mean Streets: Weegee and Hard-Boiled Autobiography." *Yale Journal of Criticism* 17, no. 1 (Spring 2004): 20–50.

———. "Multiple Indemnity: Film Noir, James M. Cain, and Adaptations of a Tabloid Case." *Narrative* 13, no. 3 (October 2005): 211–37.

"PM's Weegee Exhibits More of His Police News Photos." *PM,* September 9, 1941, 18.

"Portrait of a Man Who Ignores the Heat." *PM,* July 25, 1940, 10.

"The Press: Modest and Assuming." *Newsweek,* July 23, 1945, 74.

Pretshold, Karl. "Newspaper Delivery Strike Ends." *PM,* July 18, 1945, 11.

"Prevent This." *People's Voice,* October 7, 1944, 10–11.

Purcell, Kerry William. *Weegee.* London: Phaidon, 2004.

"Ralph Steiner at the League!" *Photo Notes,* September 1940, 1–2.

Reilly, Rosa. "Free-Lance Cameraman." *Popular Photography* 1, no. 8 (December 1937): 21–23, 76–79.

Rosenberg, Anat. "Weegee: Distortions," *Art on Paper* 5, no. 2 (November–December 2000): 89–90.

Sante, Luc, et al. *Unknown Weegee.* New York: International Center of Photography, 2006.

Sobieszek, Robert A. *Masterpieces of Photography: From the George Eastman House Collections.* New York: Abbeville Press, 1985.

"Speaking of Pictures . . . A New York Free Lance Photographs the News." *Life,* April 12, 1937, 8–9.

"Speaking of Pictures . . . These are the Exercises of Yoga." *Life,* April 19, 1937, 8–9.

"Speaking of Pictures . . . This is a Brain Operation." *Life,* November 30, 1936, 3.

"Speaking of Pictures . . . This is a Jewish Wedding." *Life,* April 5, 1937, 4–5, 7.

"Speaking of Pictures . . . Weegee Shows How to Photograph a Corpse." *Life,* August 12, 1946, 8–10.

Spivak, John L. "The Rise and Fall of a Tabloid." *American Mercury,* July 1934, 311.

Steiner, Ralph. "Can You Tell Which of These Men Took Which of These Photographs?" *PM,* September 29, 1940, 48.

———. "Faces You Like Make Likeable Pictures." *PM,* July 14, 1940, 49.

———. " 'Framing' Doesn't Necessarily Make a Picture Good." *PM,* December 15, 1940, 48.

———. "It Takes Both Thick and Thin-Skinned Photographers to Cover News." *PM,* October 6, 1940, 48.

———. "Look Again! These Photos Prove Muscles, Not Eyes, Give Facial Expressions Their Meanings." *PM,* August 24, 1941, 48–49.

———. "Repetition: Bad and Good." *PM,* September 22, 1940, 48–49.

———. "Some Photographers Make England Look Like This." *PM,* November 24, 1940, 49.

———. "These Are Real People Showing Emotion . . . and These are Models 'Acting' Emotion." *PM*, July 25, 1940, 48–49.

———. "This Is the Way to Take Fine Pictures of Children," *PM*, December 22, 1940, 48–49.

———. "To Photograph a Foreign Place . . . You Need to Get Under Its Skin." *PM*, July 21, 1940, 48.

———. "The Way People React to a Camera Is Revealing." *PM*, September 15, 1940, 48.

———. "Weegee, as Clown, Covers Circus from Inside . . . These Are Pictures He Took of the Crowd." *PM*, July 9, 1943, 12–13.

———. "Weegee Lives for His Work and Thinks Before Shooting," *PM*, March 9, 1941, 49.

Stettner, Louis. "Cézanne's Apples and the Photo League." *Aperture*, no. 112 (Fall 1988): 14–35.

———. Introduction to *Weegee,* edited by Stettner, 3–19. New York: Alfred A. Knopf, 1977.

———. *Louis Stettner: Wisdom Cries Out in the Streets.* Paris: Flammarion, 1999.

Strand, Paul. "Weegee Gives Journalism a Shot of Creative Photography." *PM*, July 22, 1945, 13–14.

Sussman, Aaron. "The Little Man Who's Always There." *Saturday Review of Literature,* July 28, 1945, 17.

Sussman, Warren I. *Culture as History: The Transformation of American Society in the Twentieth Century.* New York: Pantheon, 1984.

Szarkwoski, John. Introduction to *From the Picture Press,* edited by Szarkwoski, 3–6. New York: Museum of Modern Art, 1973.

"The Tabloid." *Nation,* June 15, 1927, 661.

"They'd Sooner Be at the Beach But, Heat or No Heat, Jobs Are Scarce." *PM*, July 28, 1940, 16–117.

Thornton, Gene. "The Satirical, Sentimental Weegee." *New York Times,* September 18, 1977, 19.

Tucker, Anne. "A History of the Photo League: Its Members Speak." *History of Photography* 18, no. 2 (Summer 1994): 174–84.

———. "Sid Grossman: Major Projects." *Creative Camera,* nos. 223–24 (July–August 1983): 1040.

"220 Minutes in the Life of a Naked City." *Cosmopolitan* 119, no. 1 (July 1945): 49–55.

Ungemacht, Ginger. "I Covered a Gang War." *Photo,* August 1953, 123–30.

Vettel-Becker, Patricia. *Shooting from the Hip: Photography, Masculinity, and Postwar America.* Minneapolis: University of Minnesota Press, 2005.

"Walter & Dave in the *PM.*" *Photo Notes,* January 1941, 2.

Weegee. See Fellig, Arthur.

"Weegee." Review of *Naked City,* by Arthur Fellig. *New York Times,* July 22, 1945, 102.

"Weegee." Review of *Naked City,* by Arthur Fellig. *Time,* July 23, 1945, 70.

"Weegee: Murder is My Business." *Photo Notes,* September 1941, 2.

"Weegee Covers Society." PM, December 3, 1940, 2.

"Weegee Photographs Society at the Waldorf." *PM,* April 18, 1941, 16.

Westerbeck, Colin. *Bystander: A History of Street Photography: with a New Afterword on Street Photography since the 1970's.* Text by Westerbeck, folios by Joel Meyerowitz. New York: Bulfinch, 2001.

"Who Reads the Tabloids?" *New Republic,* May 25, 1927, 6.

Wilson, Earl. "Weegee." *Saturday Evening Post,* May 22, 1943, 37.

Zurier, Rebecca *Art for the Masses: A Radical Magazine and Its Graphics, 1911–1917.* Philadelphia: Temple University Press, 1988.

Index

University of California Press, one of the most distinguished university presses in the United States, enriches lives around the world by advancing scholarship in the humanities, social sciences, and natural sciences. Its activities are supported by the UC Press Foundation and by philanthropic contributions from individuals and institutions. For more information, visit www.ucpress.edu.

University of California Press
Berkeley and Los Angeles, California

University of California Press, Ltd.
London, England

Designer: Nola Burger
Text: 10.75/14 Granjon
Display: Interstate
Compositor: Integrated Composition Systems
Indexer: Alexander Trotter
Printer and Binder: Friesens Corporation

Library of Congress Cataloging-in-Publication Data
Lee, Anthony W., 1960–.
 Weegee and Naked City / Anthony W. Lee, Richard Meyer.
 p. cm. — (Defining moments in American photography ; 3)
 Includes bibliographical references and index.
 ISBN 978-0-520-25183-0 (cloth : alk. paper) —
 ISBN 978-0-520-25590-6 (pbk. : alk. paper)
 1. Weegee, 1899–1968—Criticism and interpretation. 2. Photojournalism—New York (State)—New York. 3. New York (N.Y.)—Social conditions—20th century. I. Meyer, Richard. II. Weegee, 1899–1968. Naked city. III. Title.
TR820.L425 2008
770.9747'1—dc22 2007033314

Manufactured in Canada

17 16 15 14 13 12 11 10 09 08
10 9 8 7 6 5 4 3 2 1